# THE UNIVERSITY OF WINCHESTER

THIS BOOK IS A DOCUMENTATION OF

**OUTSIDES**
**A RED BULL STREET ART PROJECT**

gestalten

# CONTENTS

# FROM NEW YORK TO WUPPERTAL
## INTRO BY MARTHA COOPER

What I love about street art is that it is ephemeral and constantly changing. Looking to see who is up and where is an enjoyable quest, keeping me attuned to my environment as I walk throughout the city. I don't have to pay entrance fees to see the art or come at a particular time. It's there for all passers by to enjoy or not. Whenever I spot a fresh piece on a wall, truck, telephone booth or bus shelter, I feel a thrill of discovery. In New York City, where every surface is covered with mass produced advertising, it's a special pleasure to see something painted, drawn, sculpted, or pasted up by hand.

In retrospect, I have to wonder why no one thought to appropriate public space for art earlier. In the dark ages of the 70s, artists made the rounds with their slides from gallery to gallery hoping to find a dealer willing to represent them. Only a very few found a place to exhibit. Dealers were the arbiters, connecting the artist to collectors, critics, and museums. But even those artists who were lucky enough to have contracts with galleries were only permitted to exhibit every eighteen months or so. If their work didn't sell, they were dropped from the gallery's roster.

This was the art world when I first came to live in NYC in 1975. Graffiti writers changed all that. Instead of waiting for someone to deign to give them a show, they simply seized paint and markers and displayed their pieces for all to see. Shocking! Thirty years later the galleries are struggling to catch up as street artists, using tactics they learned from graffiti writers, have wrested control from dealers, critics and museums by finding their own exhibition spaces and putting their work out there repeatedly and continually. Instead of waiting to be "discovered", an artist can now exhibit whenever he or she chooses. Most street and graffiti artists create for the love of it, putting their work out in the world for fans to admire on site or critique later on the internet.

Since street art is an urban phenomenon, people who live outside large cities seldom have a chance to see it and when they do, they usually dismiss it as vandalism. The OUTSIDES project, initiated by Red Bull was an innovative experiment. An eclectic selection of street artists from all over the world was brought together. They were given the materials they needed to make whatever art they wanted but they had to seek out public space in the same clandestine manner as they usually would, without official permission. OUTSIDES therefore combined the frame of an organized exhibition, with the effect of the free, surprising and anonymous appearance of graffiti and street art.

The mysterious appearance of an overnight exhibition of street art in Wuppertal introduced the inhabitants to kinds of art they were unlikely to have encountered before. Anyone who took the time to follow the OUTSIDES map, or even just to walk around with their eyes open, could discover a wide range of works — serious, humorous, engaging or difficult. These unusual pieces, placed in both obscure and very public sites, challenged the viewers to ponder what art is, who an artist is, and where art should, could and usually be seen.

Thirty years ago, when I first started looking at graffiti, I could never have imagined that the idea of appropriating public space for art could become a worldwide movement. Now it seems obvious: the streets are wide open and waiting for any artist willing and daring enough to exhibit on them. Big props to the organizers and participants of

OUTSIDES!

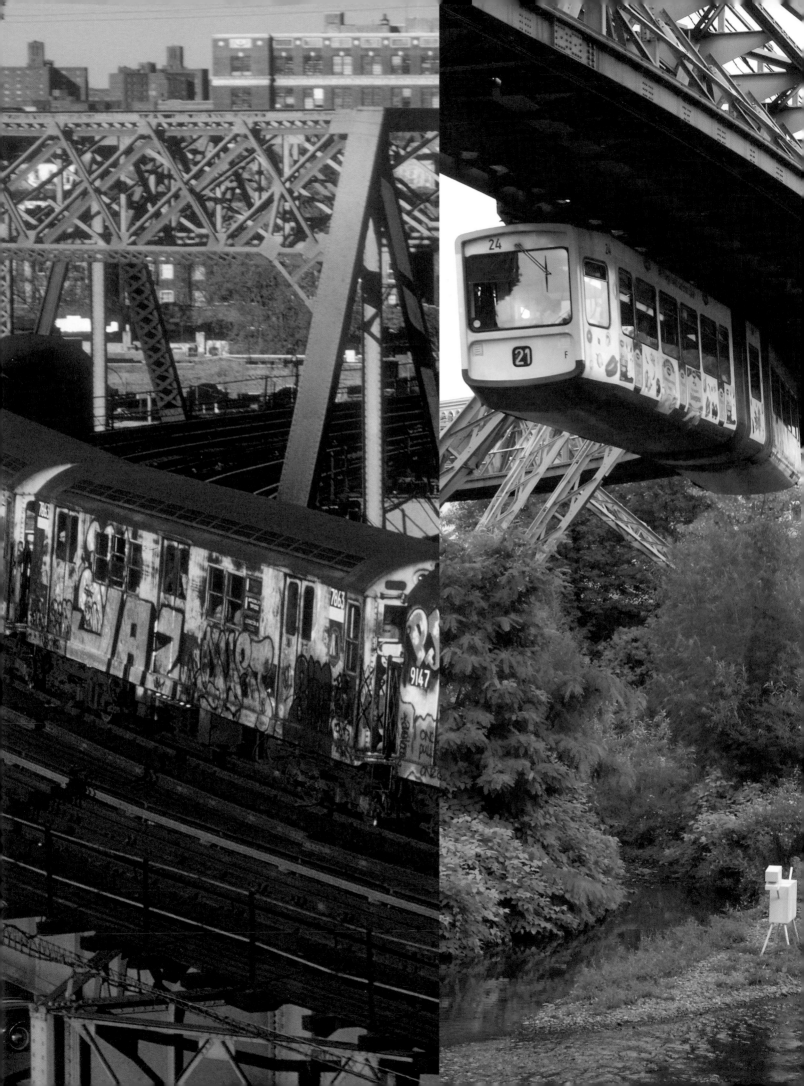

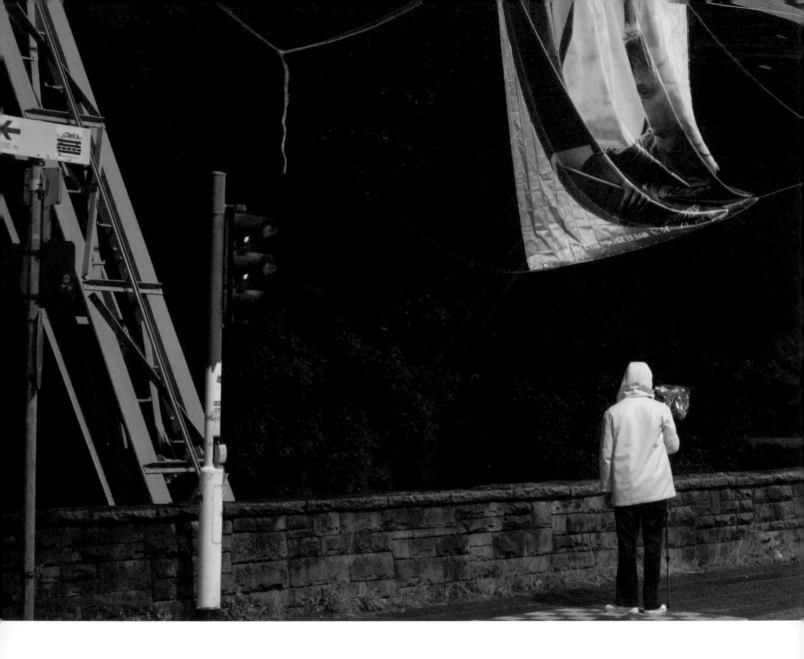

# CARPE NOCTEM
## REVIEW BY JÖRG ROHLEDER

It's about two o'clock at night when the cops arrive. Two men, neither tall nor short. Kind of ageless in the way only men in uniform can look. Moustaches? Probably. Half bald? Sure. "What took them so long?" I ask myself in this ghastly rain-soaked night in August 2006. There is already one four by six meter screenprint hanging down from the suspended monorail (known as the "Schwebebahn"). Twenty-four square meters can hardly be ignored for too long, one would imagine. Especially as it's hanging next to a main road with

four lanes of traffic driving past. This is compounded by the fact that the French performance photographer, JR, the man orchestrating this part of tonight's show, isn't exactly trying to be discrete about his prank – sporting a bright yellow raincoat and sunglasses. What's more, there is a bright light, camera and microphone pointing towards him.

Anyway, the cops certainly didn't know what to do.

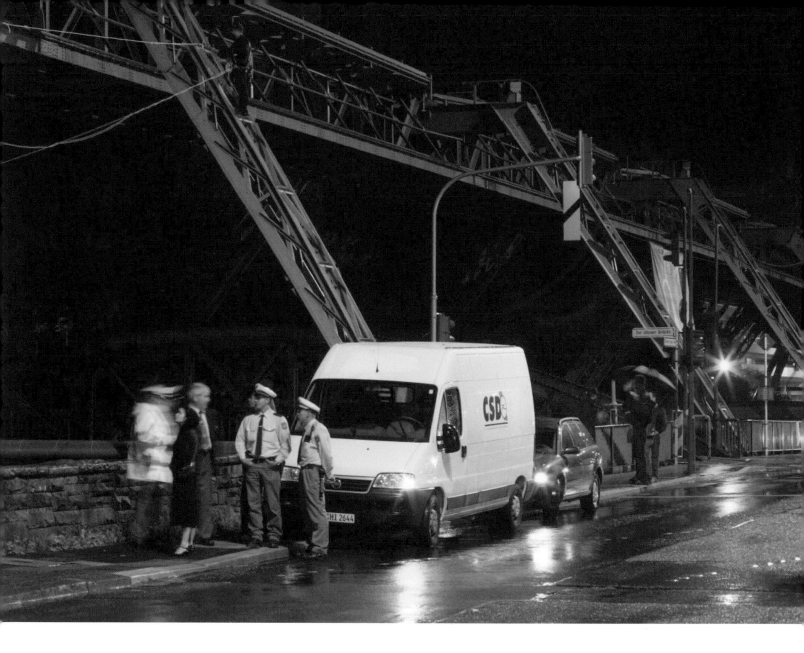

Here was an insane French artist wearing sun-glasses at night, "Bono-style", and a TV crew which was obviously fake. Then there was this young woman in her grandmother's evening gown that kept on sweet-talking them by insisting repeatedly that a permit would be handed over in the morning. After a full load of elfin-talk it happened: the men in green gave permission to roll out the second picture.

There were supposed to be three large images hung under the Schwebebahn, a defining landmark of the small German industrial town, which runs through Wuppertal like an iron millipede, symbol-izing Wuppertal's belief in a technical future during early industrial times. Unfortunately the man in charge of the millipede heard about the stunt in progress and showed up just before the second print was up.

By then the cops were lost to the "elfin-esque" eloquence.

However, the manager of the Schwebebahn didn't buy it. "10,000 volts are running up there" he kept saying, repeating it over and over like a mantra. Finally, after half an hour of talking in circles, the cops gave in and stopped the show. They seemed even more disappointed than the entourage lingering on-site. Their faces looked blank, almost forlorn, like those of cowboys not sure what to do with themselves now that they have missed the showdown.

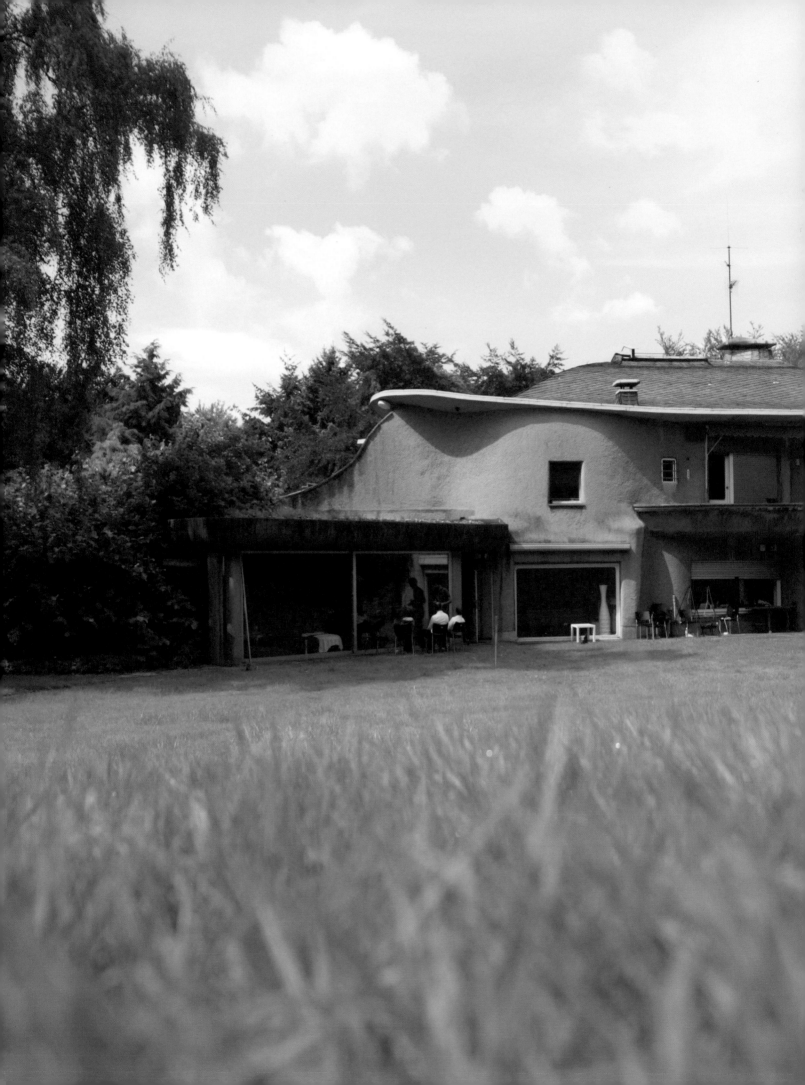

JR and his team packed up and went back to the house, the operations base for "OUTSIDES – a Red Bull Street Art" project. The project followed a simple plan: take over a medium-sized but industrial town (Wuppertal), and let 22 street artists loose on it.

"Haus Waldfrieden" was originally built by Kurt Herberts, art theoretician and owner of a lacquer factory, as a hideaway for his family and his artist/philosopher friends. But the OUTSIDES activists turned this abandoned estate into an urban separatist camp. Surrounded by a private forest, and with an 800 meter driveway leading up to it, this was an ideal place to plot, play and also recuperate. The atmosphere within operations headquarters felt like a creative class trip for paranoids on too much Red Bull.

Everybody was on alert....

Who would pull what stunt off?

When would the cops finally arrive?

They didn't arrive at all. The morning after JR's performance, Wuppertal woke up to find their rather grey city with an unexpected splash of color. A massive yellow square head (Os Gemeos) stared down at them, whilst four gigantic morbid grimaces (Blu), resembling Tolkien's "Gollum" (gone cannibalistic), accompanied them as they took the Schwebebahn to work. A playground was covered in white paint (Dr. Innocent). Installations of abstract wooden horses were all over the city (Mr. Horse), and a certain graffiti-esque statue (Mare 139) seemed to have appeared from nowhere. Then there was the writing on walls all over town which was, in fact, an act of cleaning. Zevs from Paris had done it again, leaving his lines behind with a high pressure cleaner on dirty walls.

What had happened? When had it happened? And most importantly: why had it happened? Was it vandalism? An act to reclaim the streets? Or art? People in Wuppertal started asking questions, and sleepy policemen finally started investigating....

However, they didn't really know what to look for. Perhaps those high-powered, little black Smarts that had been noticed racing around town were significant? Maybe also that French weirdo and his gang who were hanging up those pictures last night? Or would it be worth going to this one-night-only art exhibition scheduled for the afternoon, as mentioned in the little city maps that had been distributed throughout Wuppertal's inner city all day? Looking like an urban treasure map, it directed the audience to the work of the 22 artists who had turned Wuppertal into a once-off exhibition for street art, guerilla art, post graf, urban art 'outside the white cube' - or whatever you want to call it.

Let's face it, street art is so hyped these days that it's almost tacky to even talk, let alone write, about it. There are university classes discussing stencils and "a Banksy" now sells for quite a pretty packet at Sotheby's. But the Bristol-born provocateur and his American counterpart, Shepard Fairey (from Obey to Mountain Dew), aren't the lonesome heroes of this sub cultural phenomenon. A whole collective of artists grew too old for your dull graffiti and got ready to take over the space in the white cube.

What happened in Wuppertal during those 24 hours wasn't just a great prank, done by some shy arty scamps with bad skin and not enough talent for art school. The treasure map made it clear that everything happened for a reason. But what was that reason?

It was nothing less than the manifesto of a new movement that was making itself heard.

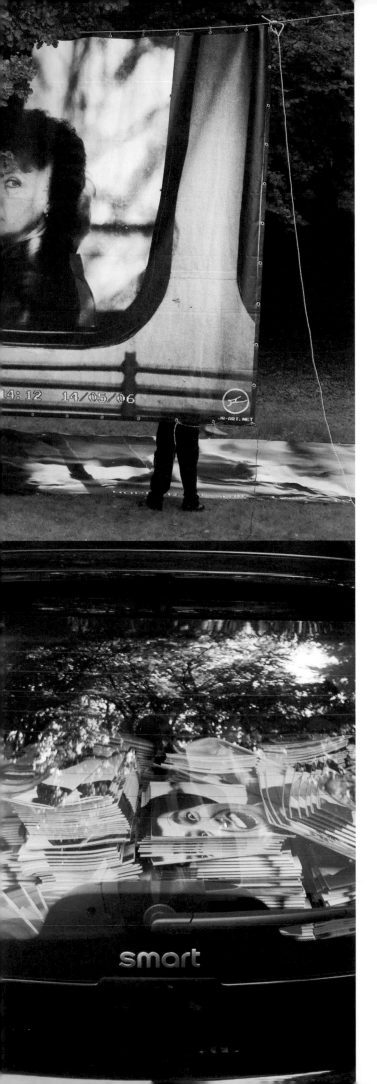

Like it or not, this orchestrated take-over of public space (space that most of us have already given up on), on such a high professional and international level, wouldn't have been possible without corporate sponsorship or the support of other institutions. Street art was, is and will be of an illicit nature and, as such, is somewhat delicate for a global brand to be associated with. This time a company didn't just order a piece of work from some hip artists for their cafeteria. This time they employed next-level cultural marketing and stepped back to make something extraordinary happen. The idea and realisation of OUTSIDES was a venture into a grey area. Not putting their brand at the forefront. Not asking for anything in return. Guerilla marketing without a logo. Just letting the artists do their thing, knowing that it would pay back in the long run.

Results have proved Red Bull right. Regional media speculated for almost two months about this particular night in August. The secretary for cultural affairs, Sabina Bartholomä, talked about "art falling out of the sky" and the local art institution followed the trend: the 'Von-der-Heydt-Museum' initiated a Street Art exhibition a couple of months later where the massive yellow Os Gemeos signature style sculpture reappeared. Miraculously.

But the greatest trick pulled off in Wuppertal was another installation of the Sao Paulo-born twin brothers. While JR was faking interviews and kidding around with cops, Os Gemeos ventured into a pitch-black abandoned tunnel and began to paint. An army of lost souls. Men, women, children. Away from the street. Hidden in the dark. Whoever wants to go and see the fear-riddled faces of those comrades down there should not forget to bring a torch. Or take a close look at page 48.

Welcome to OUTSIDES.

# PROPER GRAFFITI
## ZEVS

The French artist, Zevs, is known to many because of his spectacular "Visual Kidnapping" campaign. At the Berlin Alexanderplatz he cut a female figure out of an oversized advertisement banner, placed there by the company "Lavazza", and "blackmailed" them into making a 500,000 Euro donation to the "Palais de Tokyo" in Paris. For some time now, he has been dealing with the methods and techniques of graffiti-cleaning troops in Paris and the momentary nature of graffiti. For the Wuppertal project, he invented his Clean Graffiti Technique. He created his designs on dirty walls by working his pieces into the walls with cleaning machines, thereby creating a negative. The many dark, dirty and old industrial buildings that shape the cityscape of Wuppertal inspired him to do this work.

*Project description:*

My project consisted of creating graffiti in Wuppertal by cleaning dirt with a Karcher from the polluted walls of the city. Taking the idea of a child being given lines as a punishment in school, I proposed replicating this exercise by writing slogans using the Karcher on walls stained by urban pollution.

*What was the idea behind your project?*

The freedom of expression. Proper graffiti is a technique which I imagined while observing the street-cleaning crews of the Korrigan company during the erasing of all the graffiti in Paris in 2001.

*Why did you decide to be part of the project?*

Because I found the Red Bull proposal more interesting than a lot of other companies' proposals who try to get the most cutting edge Guerrilla Marketing strategies and tactics in order to build their businesses without spending a lot of money.

*What was special about the project?*

The reaction of people watching me working in the street was good. They were surprised, amused, enthusiastic, but never angry. It was nice to reverse the opinion of the graffiti-watcher.

*What do you think of Wuppertal as a location for this kind of exhibition?*

Nice, but I prefer metropolises like New York, Berlin, London, Paris and Tokyo.

*How much was your project affected by Wuppertal?*

It wasn't. It would be possible to do it in any other areas affected by urban pollution.

*Do you think the frame of OUTSIDES can be a role model for further projects?*

Definitely Maybe.

*www.z-e-v-s.com*

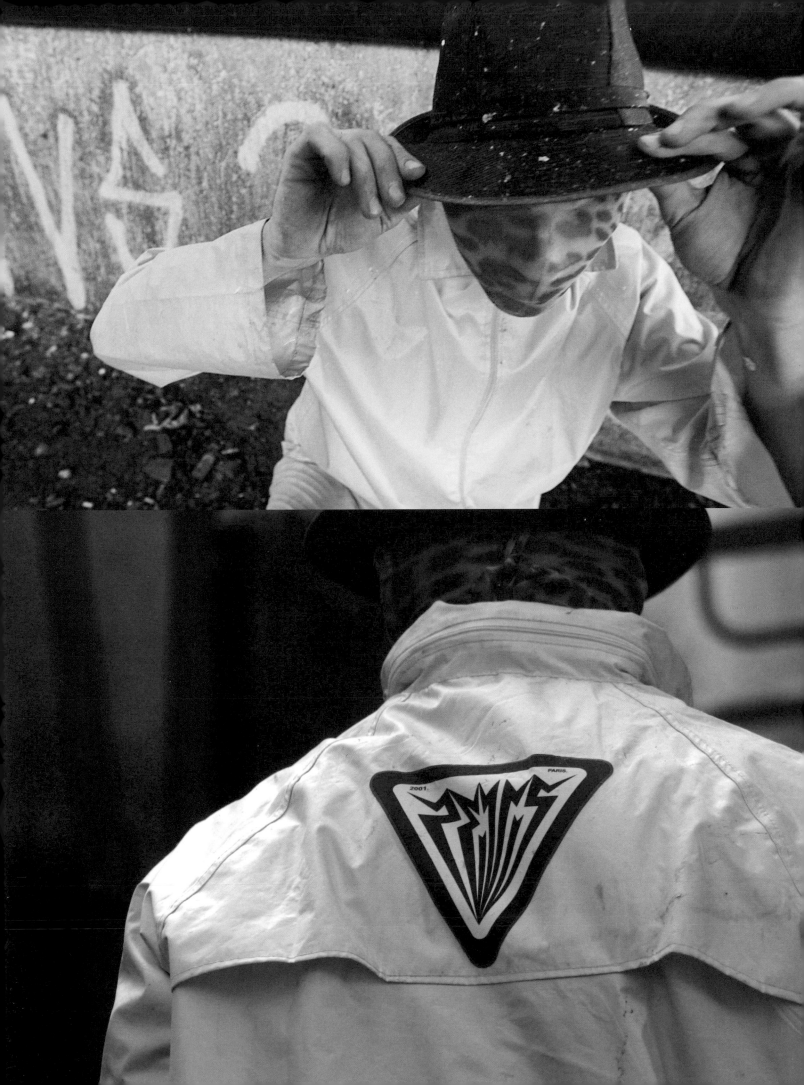

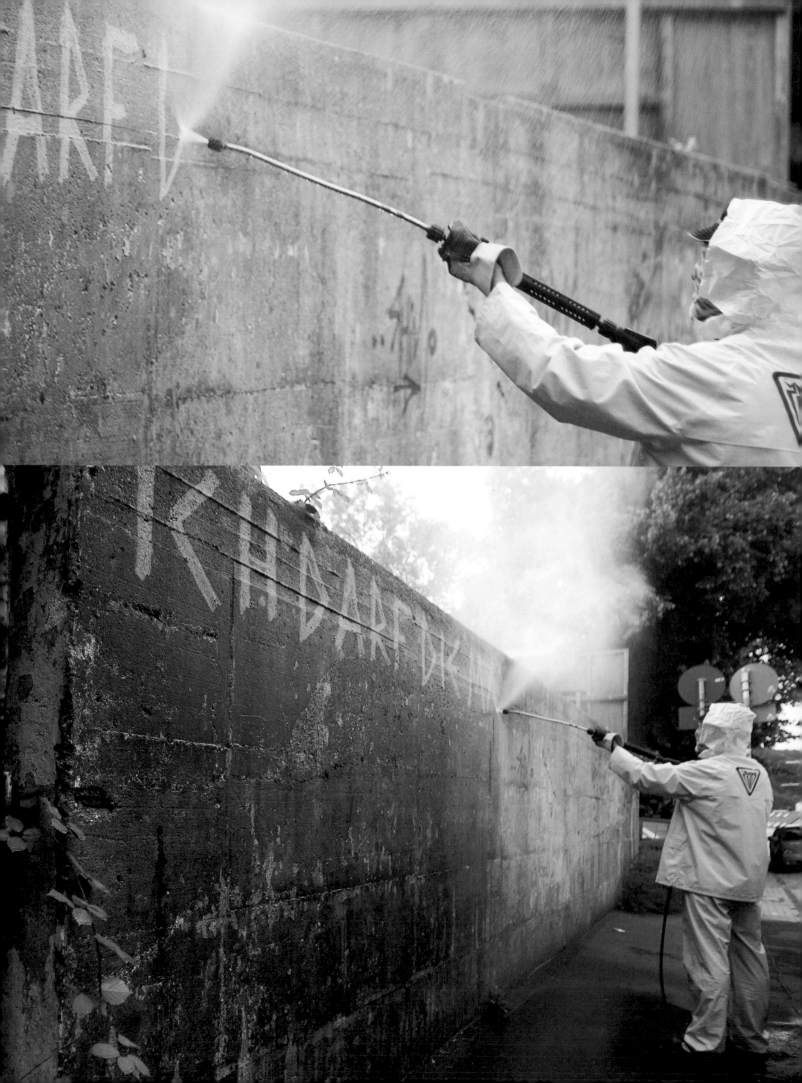

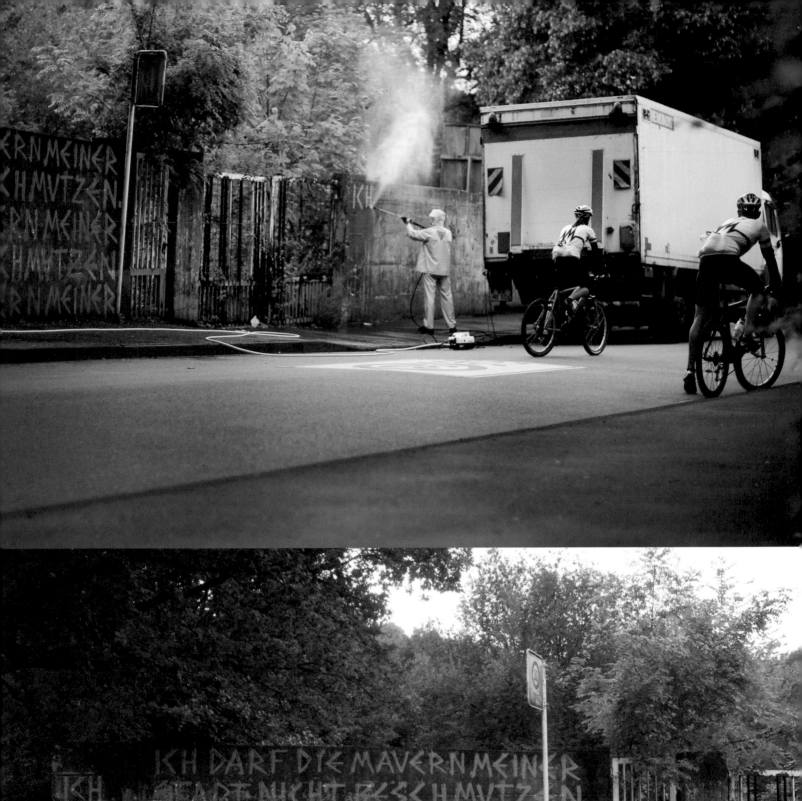

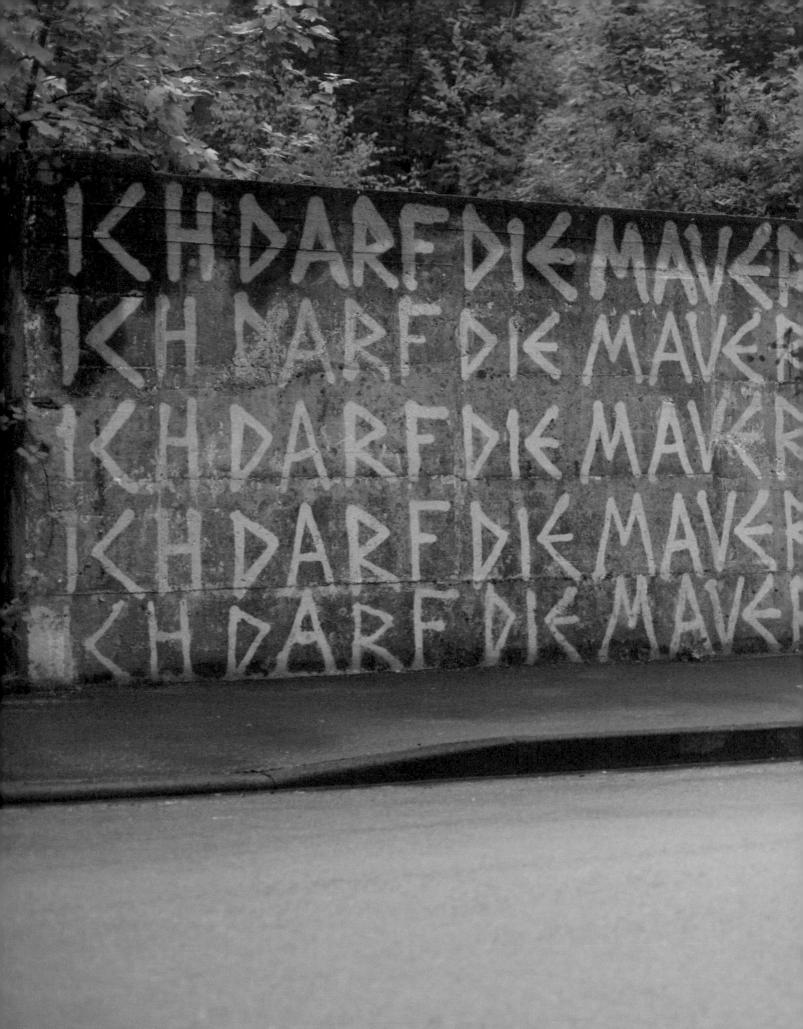

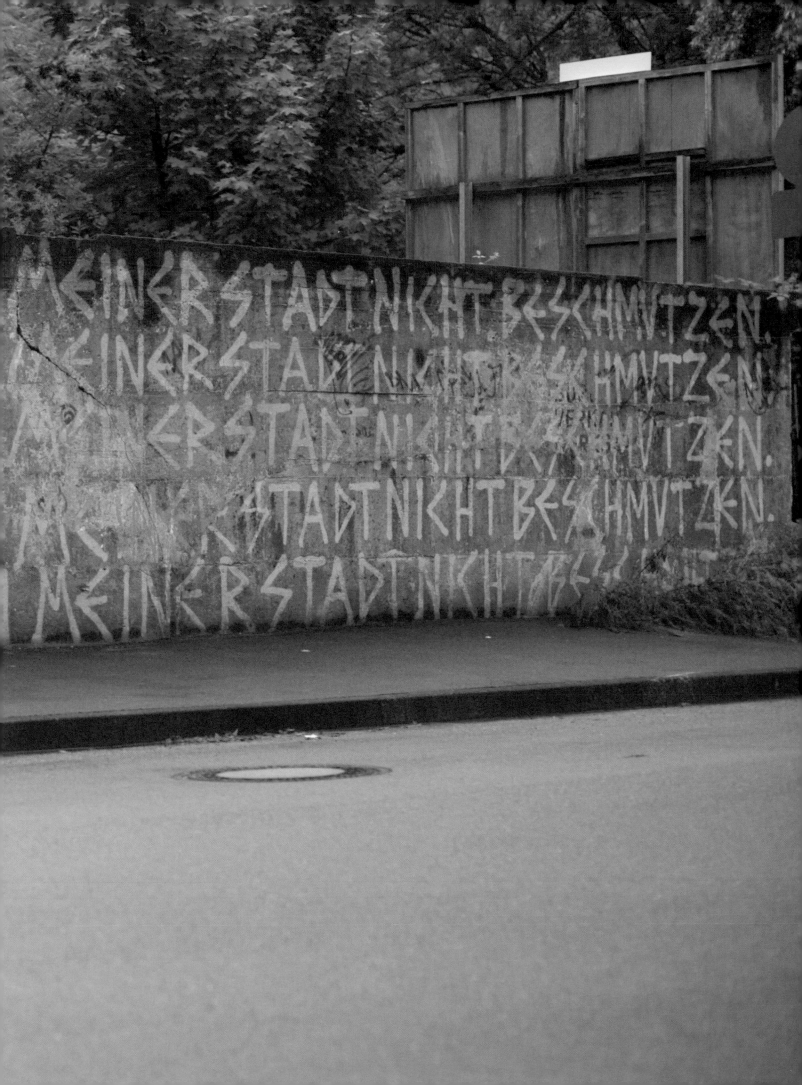

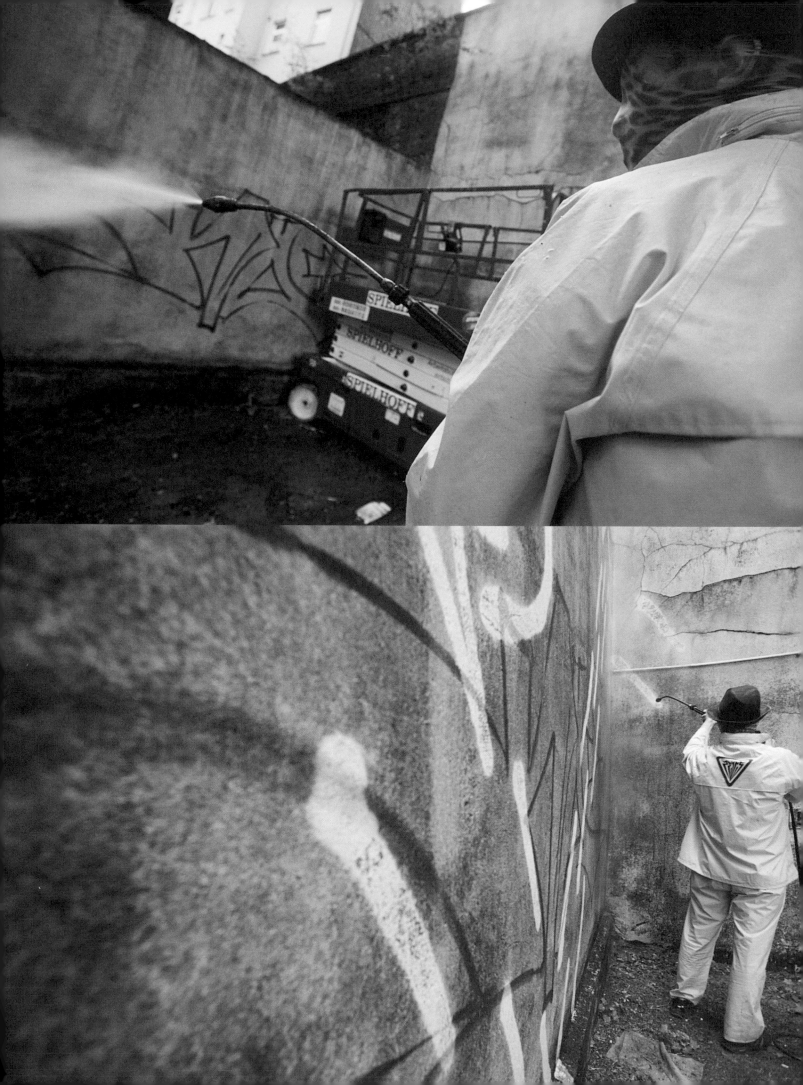

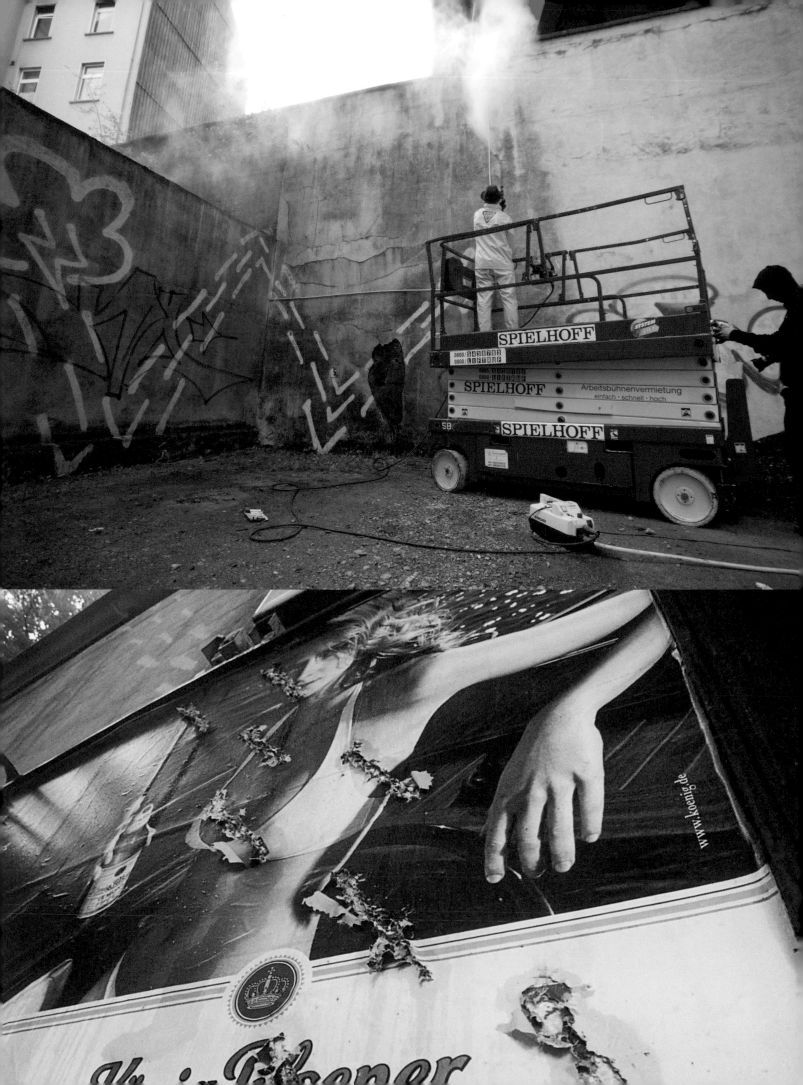

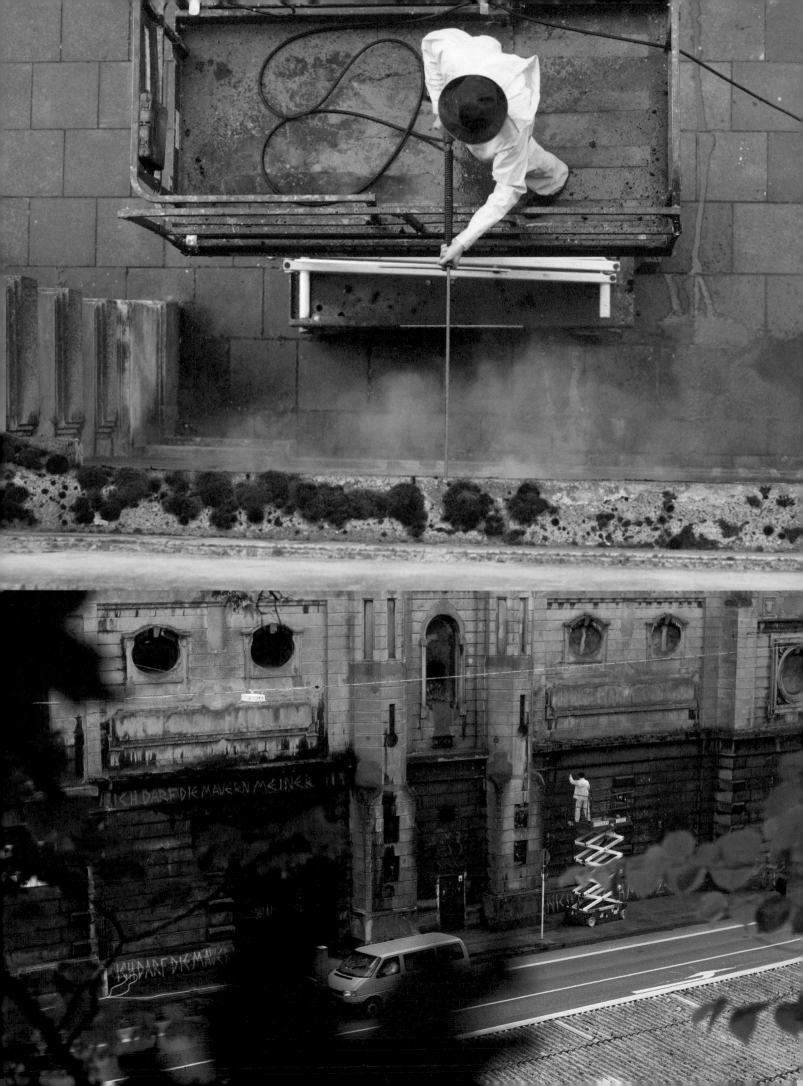

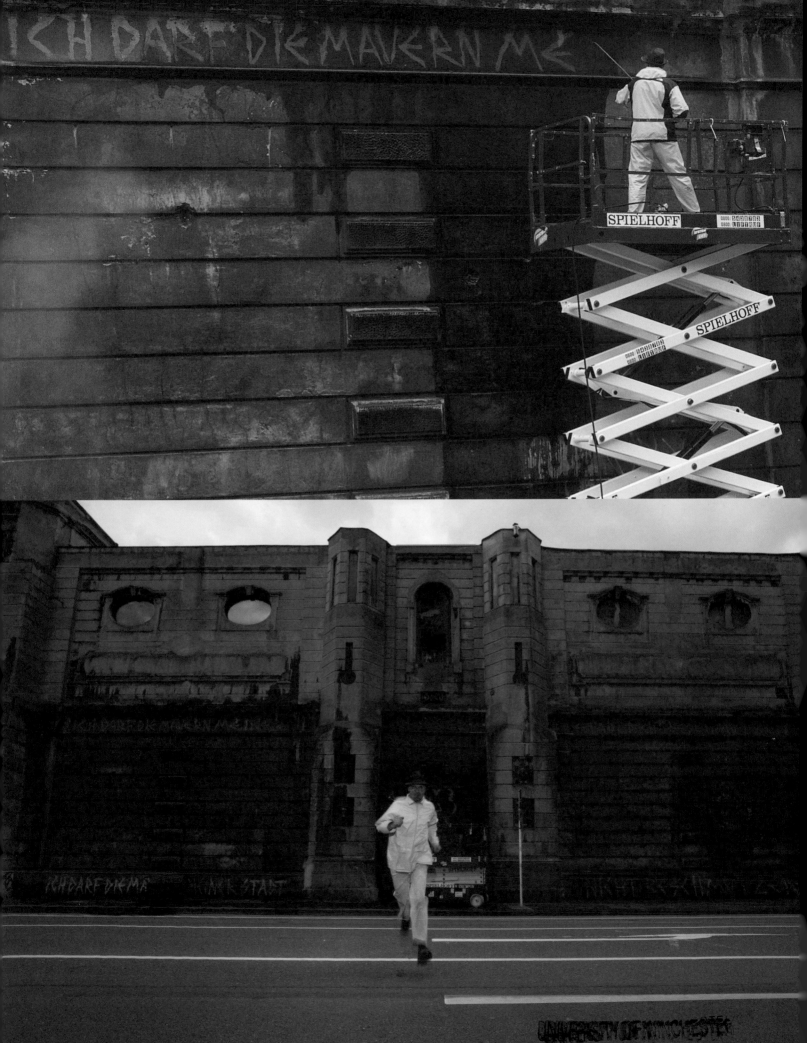

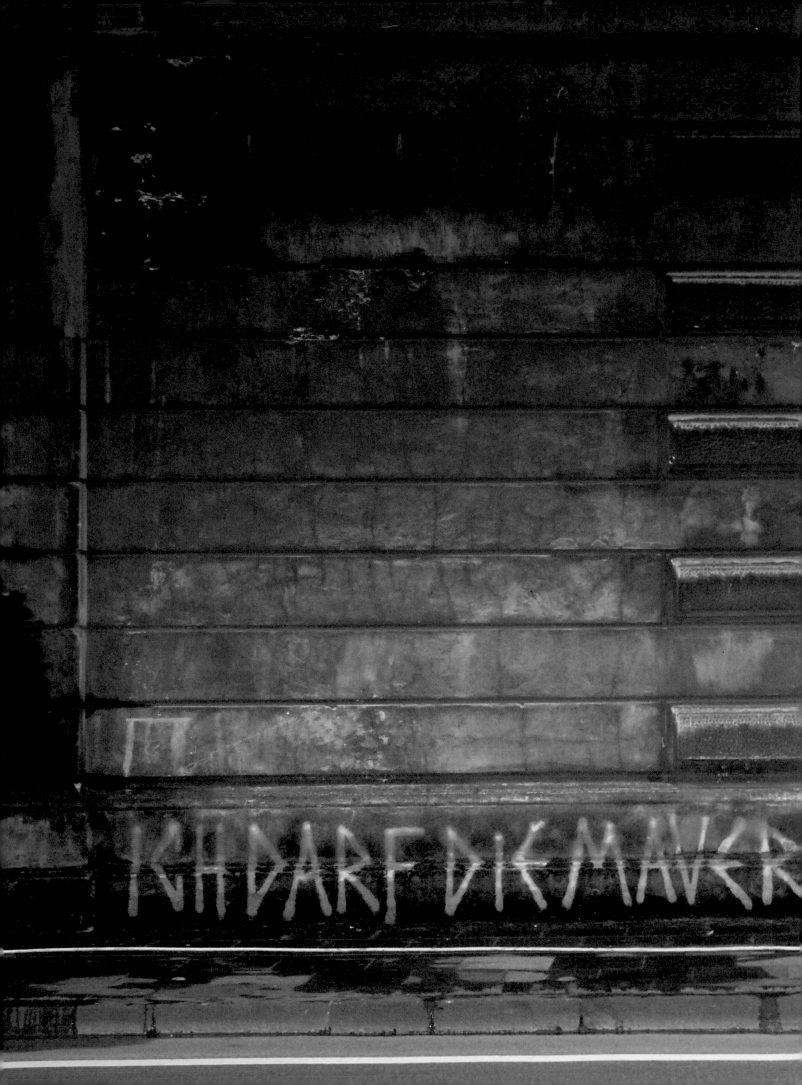

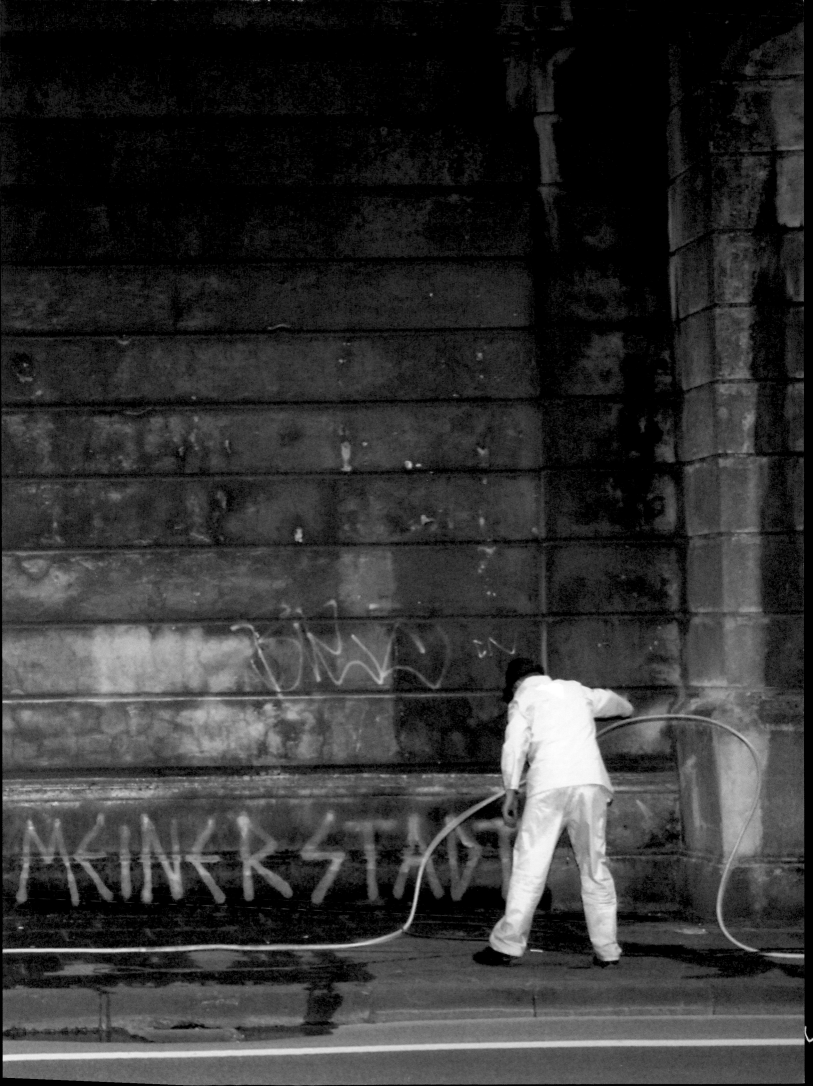

# ZASD BRANCH WUPPERTAL
## ZASD

The writer's tag or signature is an "empty signifier" according to Baudrillard (in his essay, "Kool Killer"). However, this Berlin artist works with the idea that his pseudonym functions as a brand. He deals with the mechanisms of brands and what is usually associated with them. He asks the question as to what people associate with "ZASD", his own brand that has no product or service.

## WHAT IS ZASD?
## A WRITER'S MEMORY-LOSS

In February I received an invitation from a company to come to Wuppertal to discuss a business proposal…. On the agreed date I hopped on a train to Wuppertal where I was met by a young, friendly driver. He drove me to an estate, surrounded by forest, where a futuristic-looking villa stood.

I was greeted by a casually dressed man in his thirties and was asked who I was. "Some know me under the name of ZASD because I write this name when, how and where I want. I do stuff…." He smiled softly and took me to a dining room where he offered me a seat…. "ZASD, you're probably hungry. Would you like to eat something?" I sat down.

I and the other guests, who had apparently arrived for the same occasion, were served dinner. It seemed a successfully home-cooked meal, in the way that bachelors cook shortly after they've left home (one gratefully accepts the gift and just eats until the plate is empty). The meal was accompanied by all sorts of drinks. The drinks tasted sugary, like liquid sweets. I was introduced to the other guests and, during the course of the evening, we exchanged all kinds of pleasantries. I drank a few more "sweets" and then retired to my allocated room early. I was quite tired from traveling and wanted to be rested for the business talks with my hosts the next day.

In the middle of the night I suddenly woke up. I couldn't go back to sleep and my pulse was racing. I looked around. Where was I? I couldn't remember anything. I got up to look in the mirror. The moon was reflecting in the glass. I looked at myself but couldn't comprehend the image that was reflected in the mirror. I didn't know who I was anymore, didn't recognize myself. I had no past, no childhood, no youth and no family or friends. I staggered through unconnected thoughts. Who was I? I was shaking and tried to get back to sleep.

The next morning I went to breakfast. One of the hosts greeted me, "Good morning! Did you sleep well? Would you like something to drink?" He offered me a drink in a can. I poured it into a glass and asked myself again who I was, and also who all these other people were.

One of the hosts asked me in a familiar, friendly way, "How long have you been working for ZASD?" I didn't understand his question. After a short silence I said, "I have no idea what you're talking about!" He said, "No, of course not! How modest you are. But, now just between us, how's business with the street? The street… that's the place for a successful future, isn't it?" I replied, "What kind of business?"

"Well, ZASD for example, your company, does world-wide business!" I stumbled in my ignorance. To me, the whole setting in which this conversation took place seemed to be very important, everything

seemed very important. I had the feeling that it would be a good idea to slowly feel my way through the conversation, then maybe at the end I would find out what it was all about. I stammered like a schoolboy who had been caught dreaming in class, "Yes, yes, world-wide, exactly. But do you have any idea what ZASD actually sells?"

He replied, "Well, now you're really putting me to the test. To be quite honest, I don't have a clue. But that doesn't really matter, does it? The important thing is to sell something to someone. One just has to find out what one can sell, ha ha!" He grinned mischievously and seemed very friendly and well-meaning as he added, "We would like to have you as a partner."

I tried following the subject of the conversation, but I had difficulties breathing and beads of sweat slowly started to form on my forehead. I was thinking, "Who am I? What's going to happen to me? How is this going to continue? ZASD … world-wide business … what kind of brand is that?"

I had to find out more about it. It was the key to my memory - it had to be! I didn't let on anything and asked my friendly business partner, "Tell me, in which cities did ZASD come to your attention?"

"Ah, your new corporate design, you cunning fox! It's getting a good response, I take it? I personally like it a lot. And your new branches in Madrid, Budapest and Helsinki! Yes, and even here in Wuppertal! But back to the subject… are you ready for a promising cooperation?"

I still had no idea what he was talking about. I pulled myself together and said, "I need time to think things over, and I don't feel too well." He said, "Fine! Whatever you say. Have a rest in your room; we can talk about everything else later." He winked at me. "Another drink?" At first I refused, but then took a sip out of politeness. The drink was sweet and didn't taste good. I went to my room and took a shower. In my wardrobe there were five clean,

anthracite-colored suits and various shirts and ties. I took out one set and dressed without paying particular attention to this style of clothing. I sat down at the desk and found a ballpoint pen with a "ZASD?" logo.

On a piece of paper I wrote: Madrid, Budapest, Helsinki, Wuppertal.

"What is ZASD?"

After resting for a while, I went to the salon, determined to find out more. Why was I here? I was greeted enthusiastically in an open and relaxed atmosphere. "Are you feeling better? What do you think about our offer?"

"I have to check first with my branches in Madrid, Budapest and Helsinki."

"Great! Of course! That's a good start!" He cleared his throat and continued in a more insistent tone of voice, "I suggest that we speed up the whole business. We will provide you with a plane and will book all your hotel rooms. You shall not want for anything. That way you can, in your own time, come up with an independent, creative position concerning our offer." I started trembling slightly. All this was unsettling to me. I thought, "Who am I? What is ZASD? Why on earth would a company that owns private airplanes want to cooperate with this obscure brand ZASD? What kind of value does this brand have for the world?"

One of the hosts chuckled happily, "We are looking forward to a possible cooperation with your brand." He seemed to be a really nice man. I helped myself to another can from the small fridge which stood within close reach on a little table. Now it tasted strangely pleasant, like a vague memory, part of a life that I already knew and which belonged to me. I was desperate for memory, for a Self. I noticed that a picture was forming in my mind: ZASD – a globally operating brand. I was part of this company and obviously in a key position.

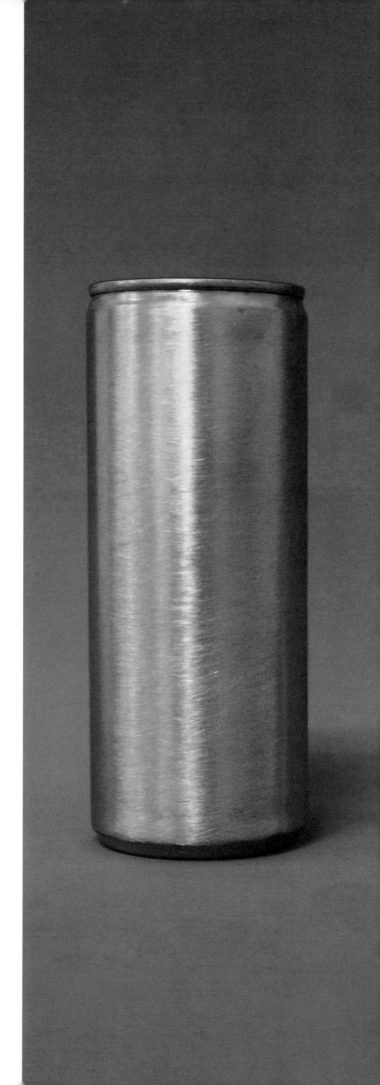

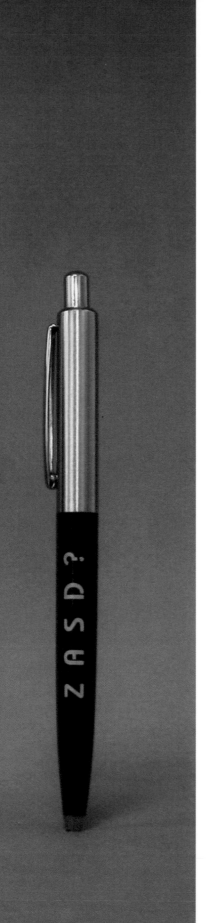

I could still be successful. I saw myself as a happy family man and as an important businessman, keeping everyone around him busy. I was starting to remember a little bit about who I was. I was starting to find my feet again.

I had to find out what kind of products ZASD sold and what terms and conditions my company required for cooperation. Then I had to come back to Wuppertal to finalize the agreement.

I said to the group, "Great. Thanks for the offer; I will consult with the company. Please make all the necessary arrangements."

"Wonderful! Then take a driver and go to the airport. We will take care of everything else as of now. In each case, the hotel will be booked in close proximity to your local branch. Good bye!"

"Good bye."

I took my briefcase, left the house and got into a car that was already waiting at the entrance. I was sweating, my pulse was racing and I clearly felt my heartbeat in my chest. I had to concentrate on not panicking.   "To the airport please."

...On arrival in Madrid. I can't stop sweating. It's awful. I need to get out! I'm thirsty. What is ZASD?

I'm looking for the ZASD headquarters but I can't find them. Instead I come across some writing at a construction site. "ZASD - proximamente" (ZASD – coming soon). So ZASD would be opening a second branch in Madrid. People are passing the construction site. I am not feeling well and am swaying but I have an idea: I take pen and paper and ask passers-by what ZASD could be, what products they associate with the name. I get all kinds of answers: computers, an insurance broker, sportswear, a bank...

ZASD seemed to be a huge brand! Soon I would know more!

The next morning I left for Budapest.

Unfortunately I was sick in the plane's toilet, but thankfully there was a wide selection of drinks on board . In my desperation over my lost Self, I was at least able to order the drink I had grown so fond of.

On arrival at the hotel I began to run a fever.

I crawled into bed and saw blurred pictures of black blotches and lines, sometimes single letters that were displayed on the front of a house. I heard voices in a whistling wind. Then I saw myself in a hoody.

There were banknotes on the nightstand. I took them and threw them in the air and covered my body with the money.

I seemed crazy. Hyped-up, I set out to find the ZASD headquarters in Budapest. ZASD – the key to the world, to my future, to my past.

I found a vacant, derelict palace at a central spot in Budapest, where a ZASD logo was clearly visible. What did that mean? I couldn't get into the palace as there was a fence around it.

Again I asked passers-by about the brand "ZASD". Again I got various answers: a watch-maker, a car brand, meat products, writing utensils, even an energy supplier etc.

How broad the ZASD product range was! I was in turmoil inside; I just had to find out! I also had to successfully close the deal. Who was I? I wanted success and I was so close!

I took a taxi to the airport and flew on to Helsinki. Gradually planes were becoming like local public transport to me.

The ZASD Finland branch was located in an office building.

I rang the door bell. No one opened. The door was open. I went inside. The building was empty.

Here too, property was vacant and marked with the logo of the alleged corporation ZASD. For heaven's sake, what did this all mean?

I heard footsteps in the building. Maybe a colleague! Maybe this person could give me some information. The footsteps came down the stairs. A security guard stared at me and came directly towards me. He held up his club and threatened me. I turned around immediately and ran out of the building and back to the hotel.

I took another can from the mini bar. My heart was beating wildly, I was afraid. I was afraid of dying. My eyes were wide-open, my mouth dry. I needed something. I wasn't in control of myself anymore. I had no Self, only the memories of the past two days. I vomited several times. I wanted to consult a doctor but then thought, "Fly to Wuppertal, everything will be fine! Close the deal."

I stumbled to the taxi rank, threw myself on the back seat and left Helsinki.

I was missing something, my heart was beating even faster. It felt like it had stopped, I couldn't distinguish the heart beats from each other anymore. They were like one continuous, frozen beat.

In Wuppertal I was feeling a little better. I looked for the ZASD branch and found it! Again, it was the same scenario; the building, in a shopping street in the city center, seemed to be vacant.

Again, I asked a few passers-by questions about the brand ZASD.

I decided to use the answers as a basis for my negotiations. ZASD had to be powerful even though its property was vacant.

With my last strength I drove up to the villa. I was greeted politely yet determinedly. I was led into a small room where I found my already-familiar business partner. Nervously, I clicked my ballpoint pen in my trouser pocket.

He said, "We offer that our company acquires your established structures. Our logo will be displayed next to yours. Your brand provides enough space to be associated with our products. Even more, your brand can accommodate our brand because you have space for every possible product in the world. You are nothing and everything. How much do you want? Just say how much." The employee took my hand and squeezed it. My body started to hurt again, I knew I would lose consciousness soon. I desperately needed help. I got up with the words, "I am sorry, but I need to leave you now. I can't accept your offer at this time. We will stay in contact. Please excuse me."

I left the house and walked to the street where I took a taxi to the local hospital. They kept me there for five days. After three days I regained my memory.

After another three days I felt sympathy for all those who commit their lives to the highest possible profit.

*www.thomasbratzke.com*

PROXIMAMENTE

CLAMORES
TÁCUL        Alburquerque, 14 · Metro Bilbao · Tel. 91 445 79 30
SAN SEBASTIÁN DE LOS REYES
del 24 al 30 de agosto '06
ditorio Parque de la Marina (Recinto Ferial)
ctuaciones estelares

SAN MA

Melendi
VIERNES 25 · 22:30H.

FIESTÓN
onselectrónica

festival

veranos '06
MAR              jardines
                 sabatini

LA FUGA

Presentando su último disco

GRUPO INVITADO

Dike

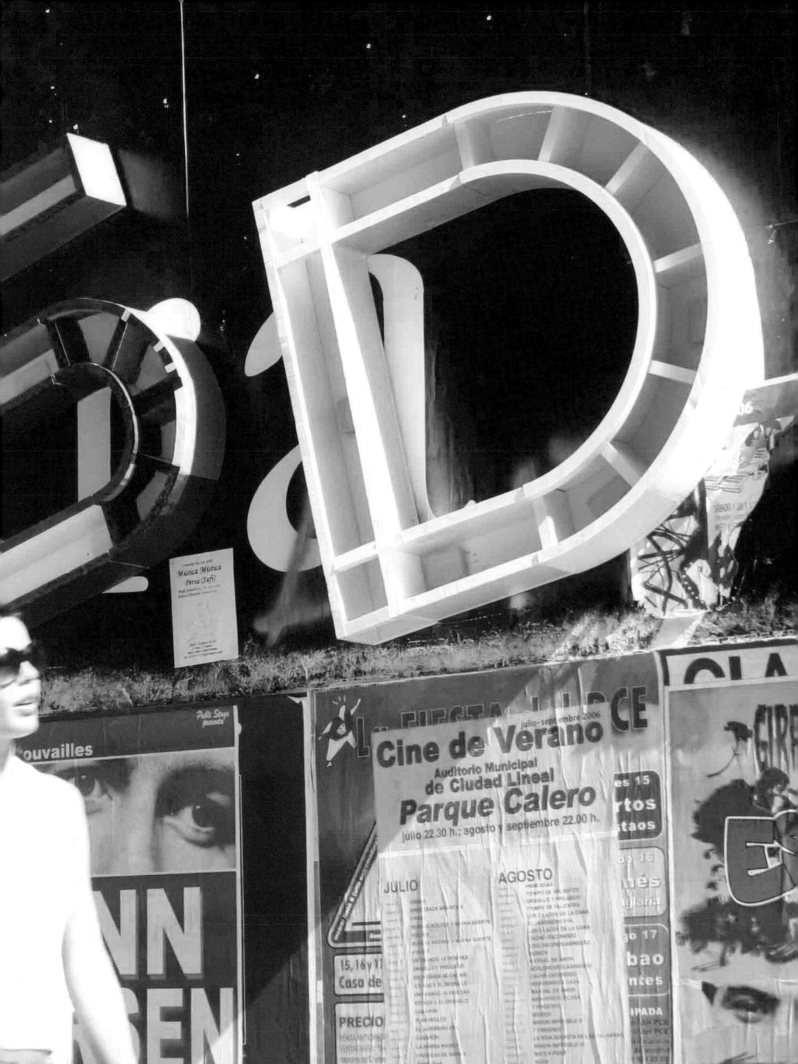

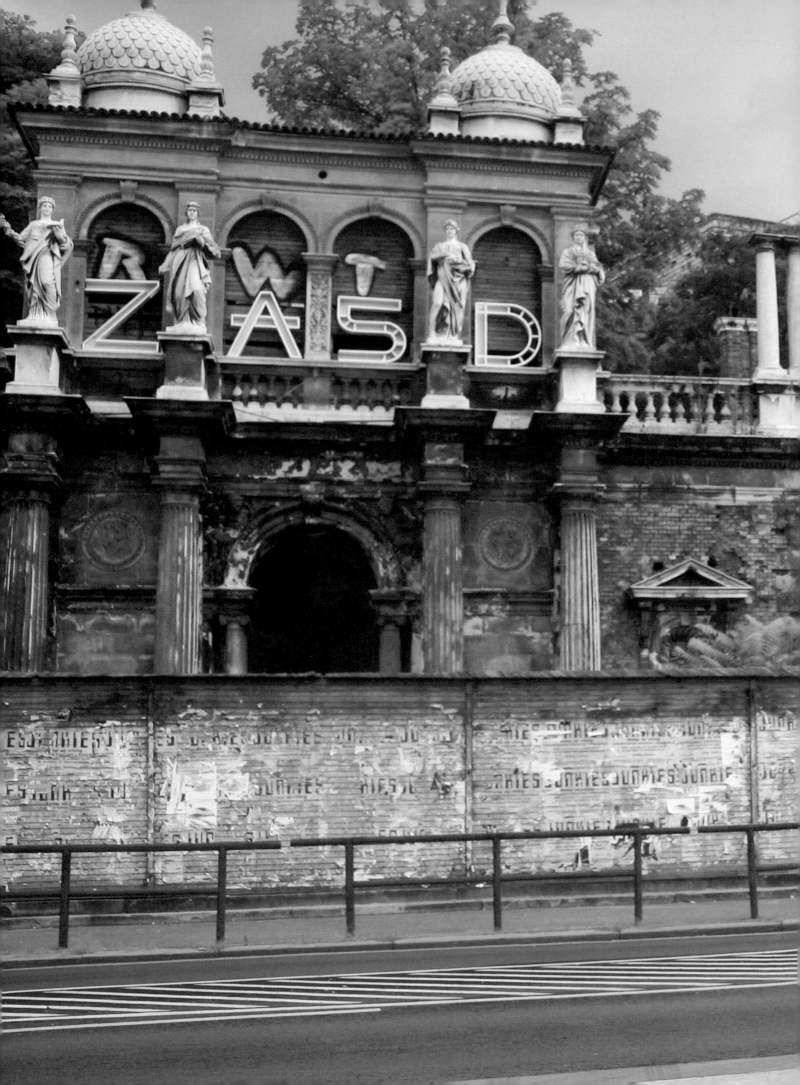

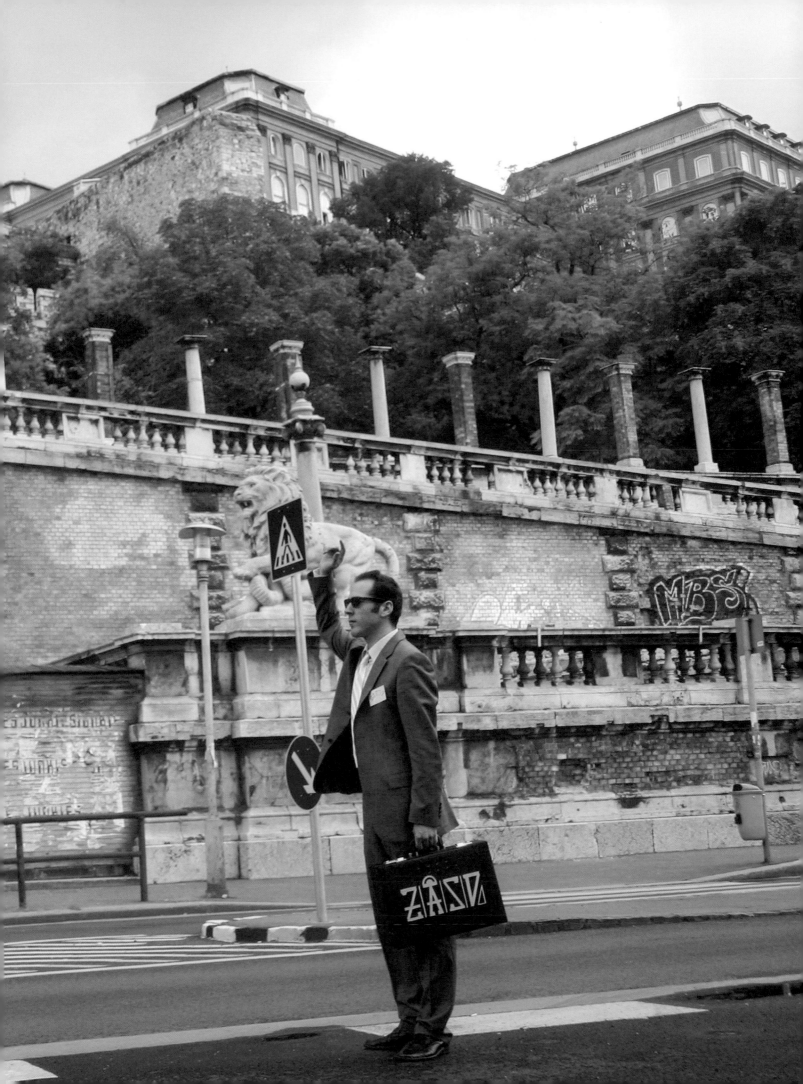

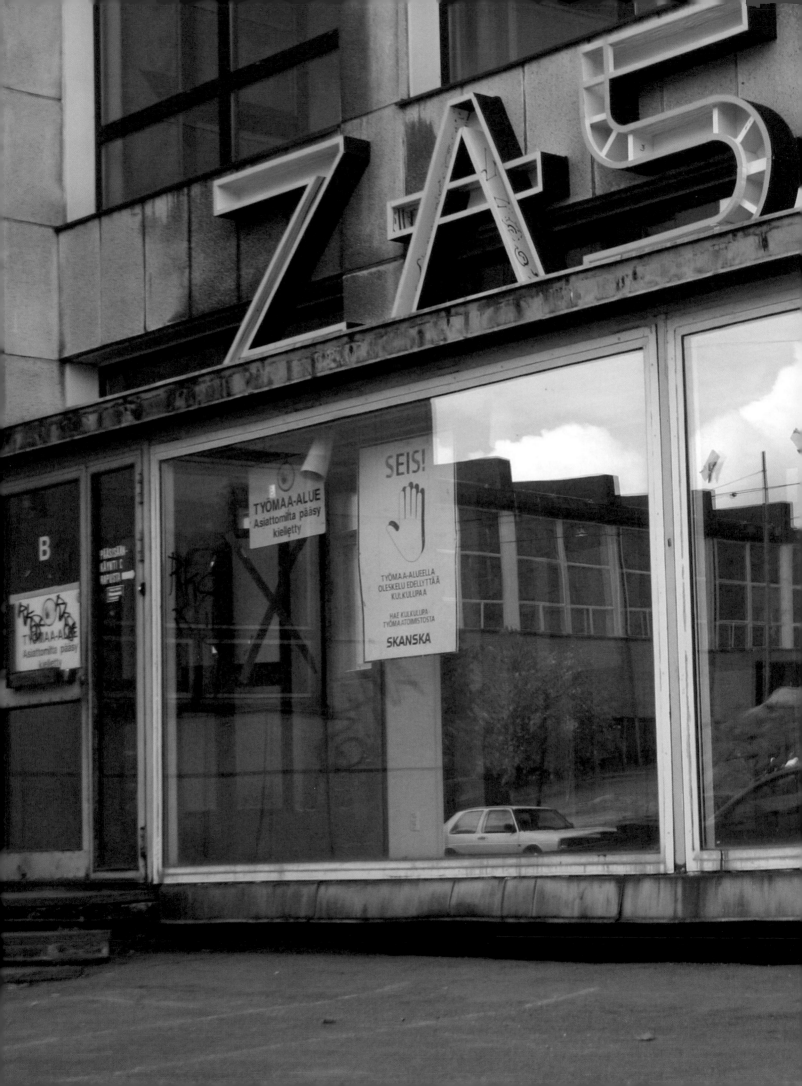

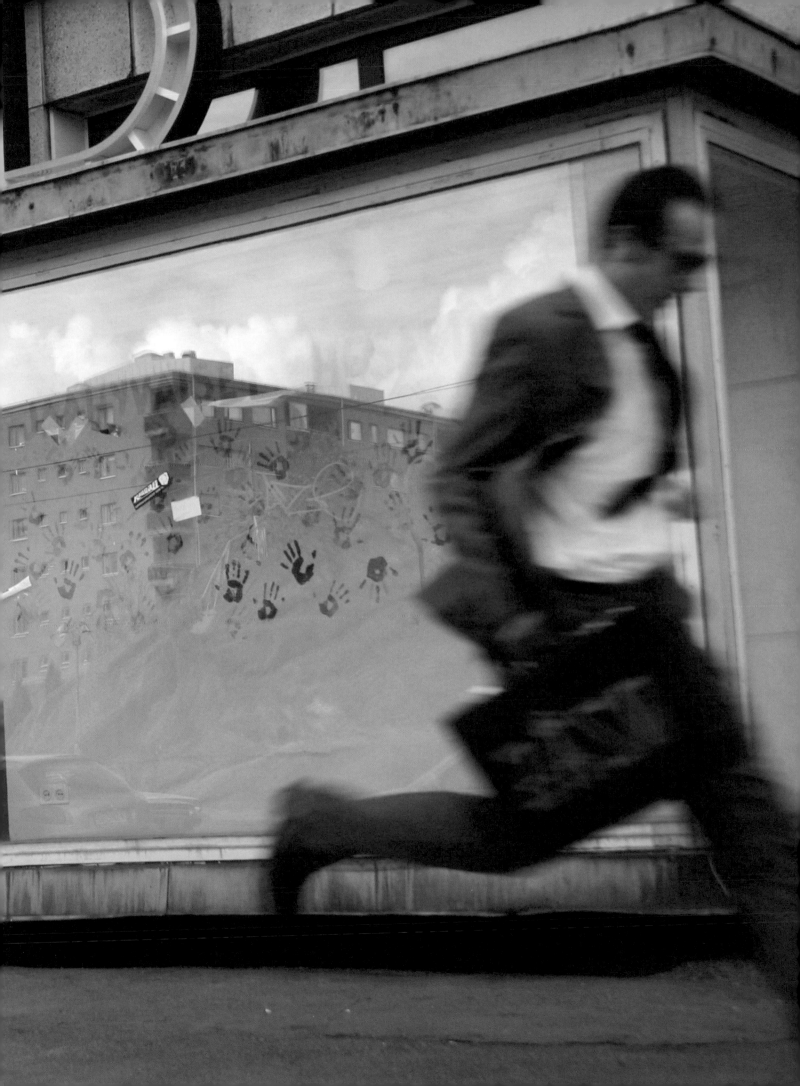

# POESIA
## OS GEMEOS & NINA

Over the past few years these Brazilian artist twins have left traces all over the world with their elaborate and detailed work. They have successfully made the transition from street to world art and get invited to renowned institutions such as Art Basel in Miami (in which they exhibited in 2005). Nevertheless, they still draw inspiration from the power of the street and maintain strong relations with the public space. In Wuppertal, they worked in a tunnel at the same disused train track as the Japanese artist couple, Kami & Sasu. There, they dedicated themselves to the subject "poetry" and the romantic era between '39 and '45 in Europe. They played with the contrast which resulted from the aesthetics of the tunnel and the original function of the place in interaction with its return to nature.

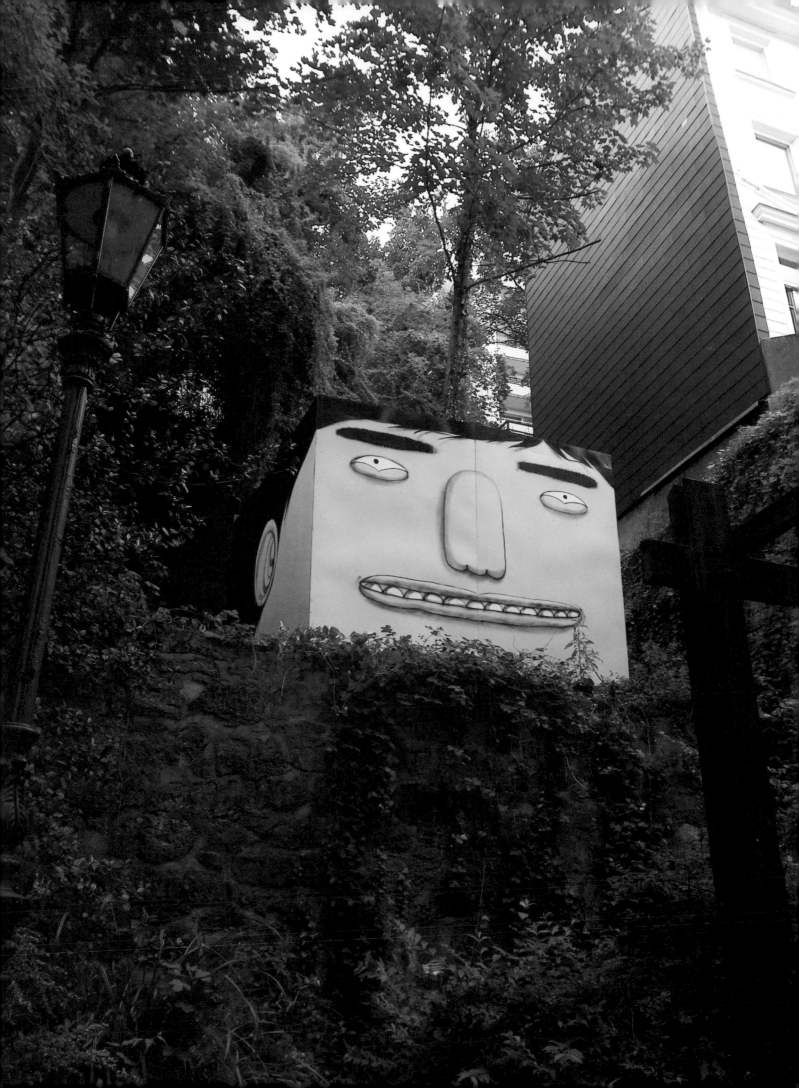

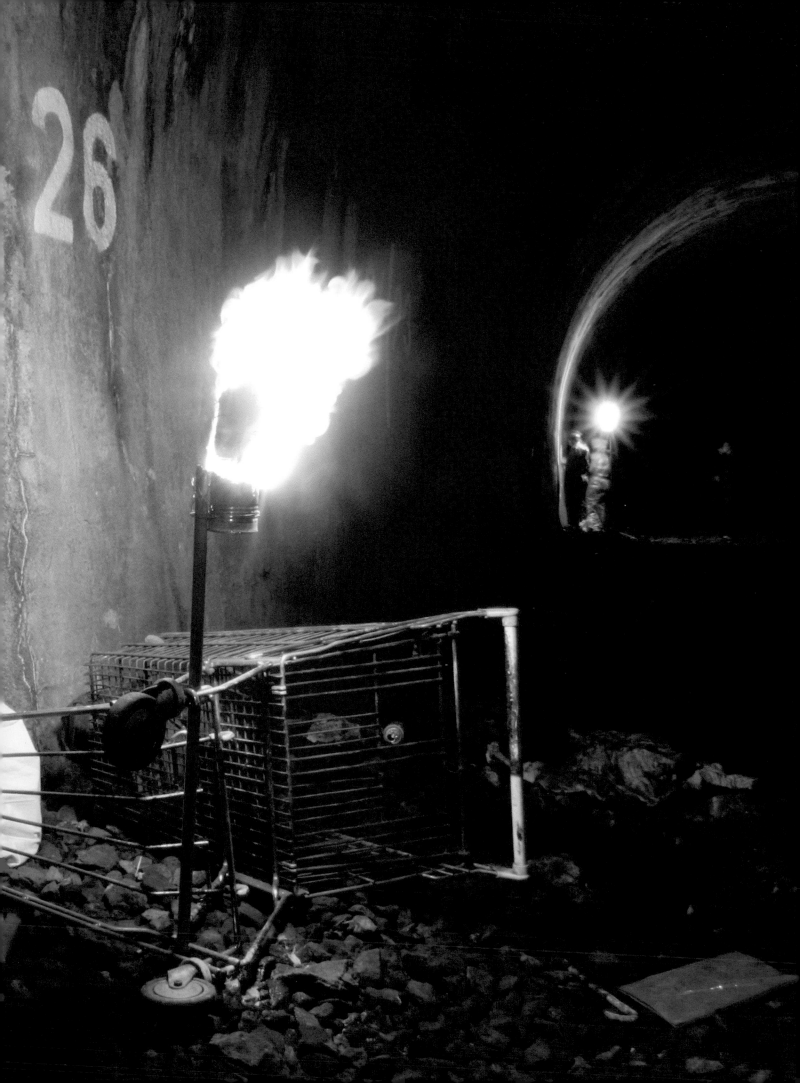

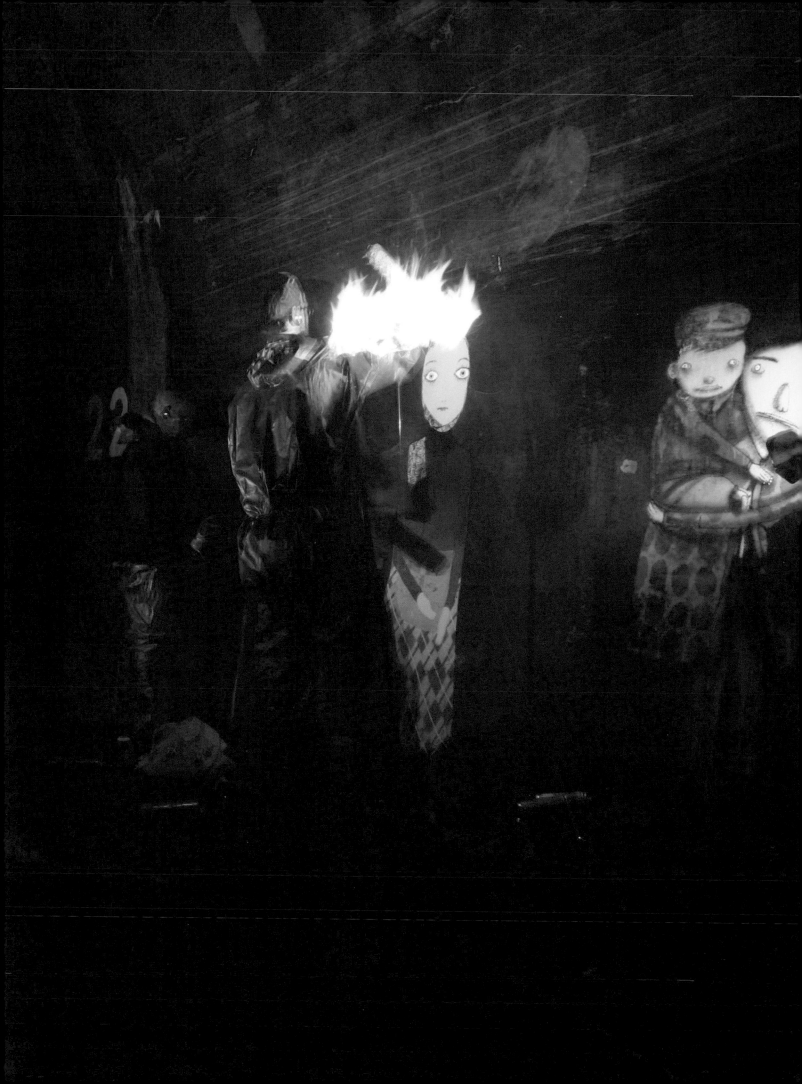

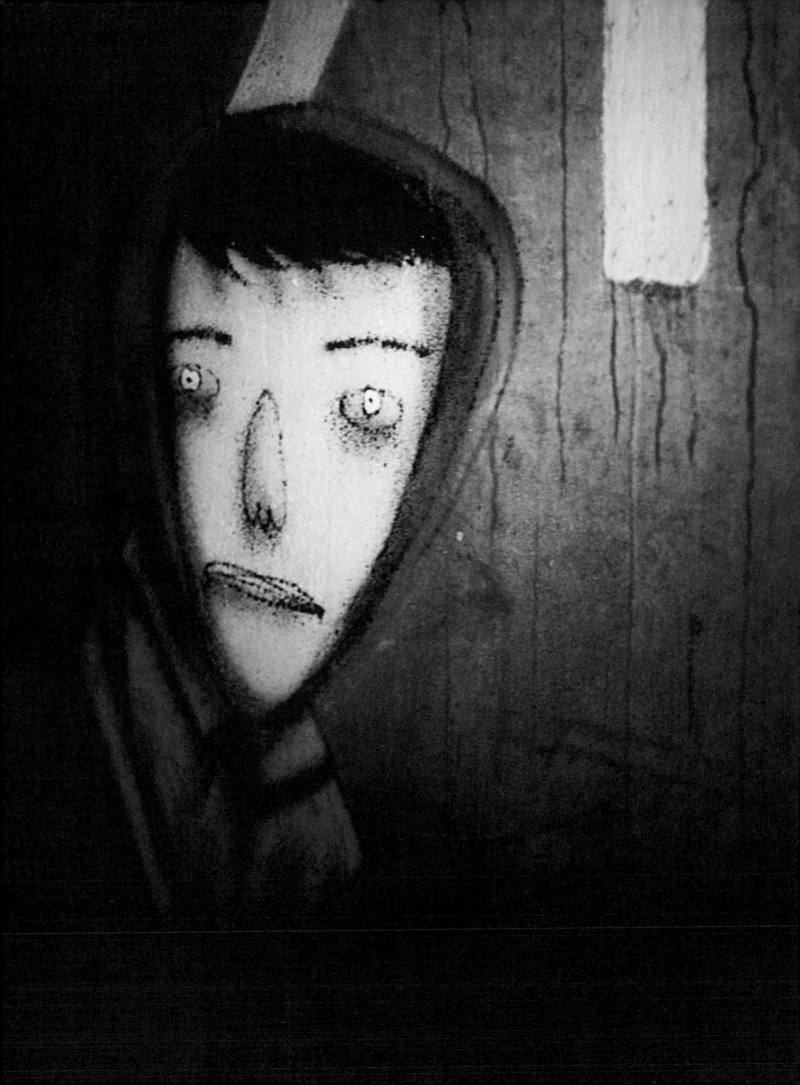

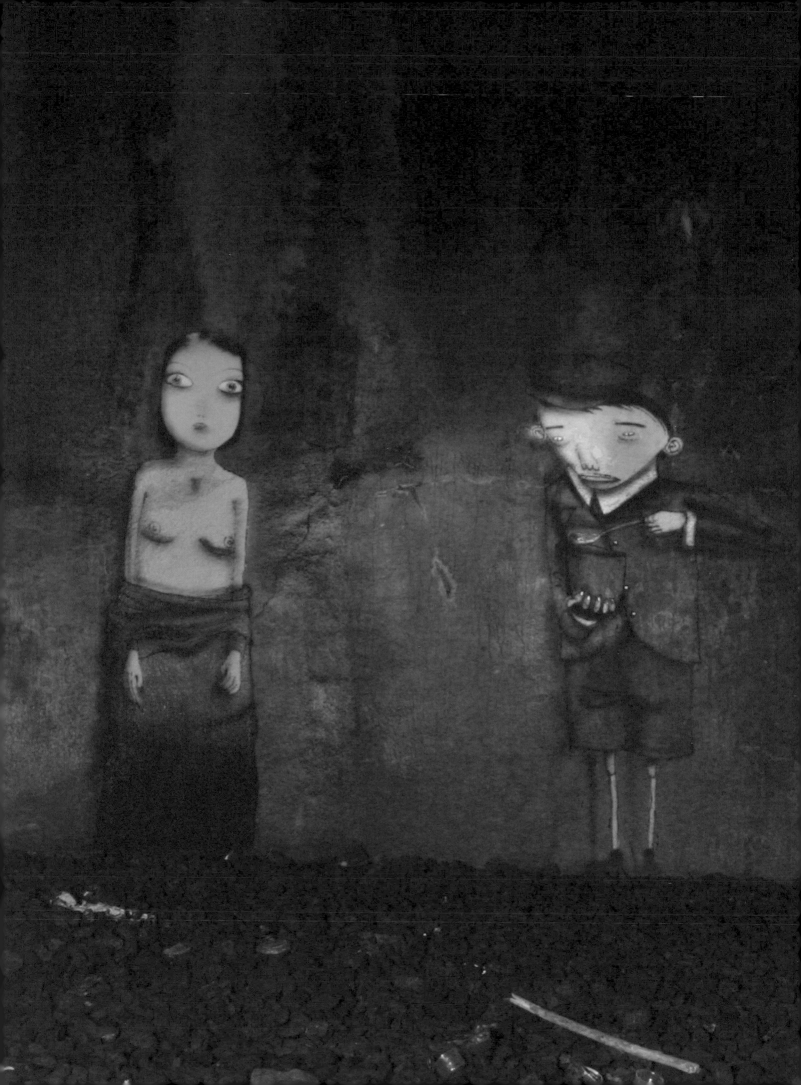

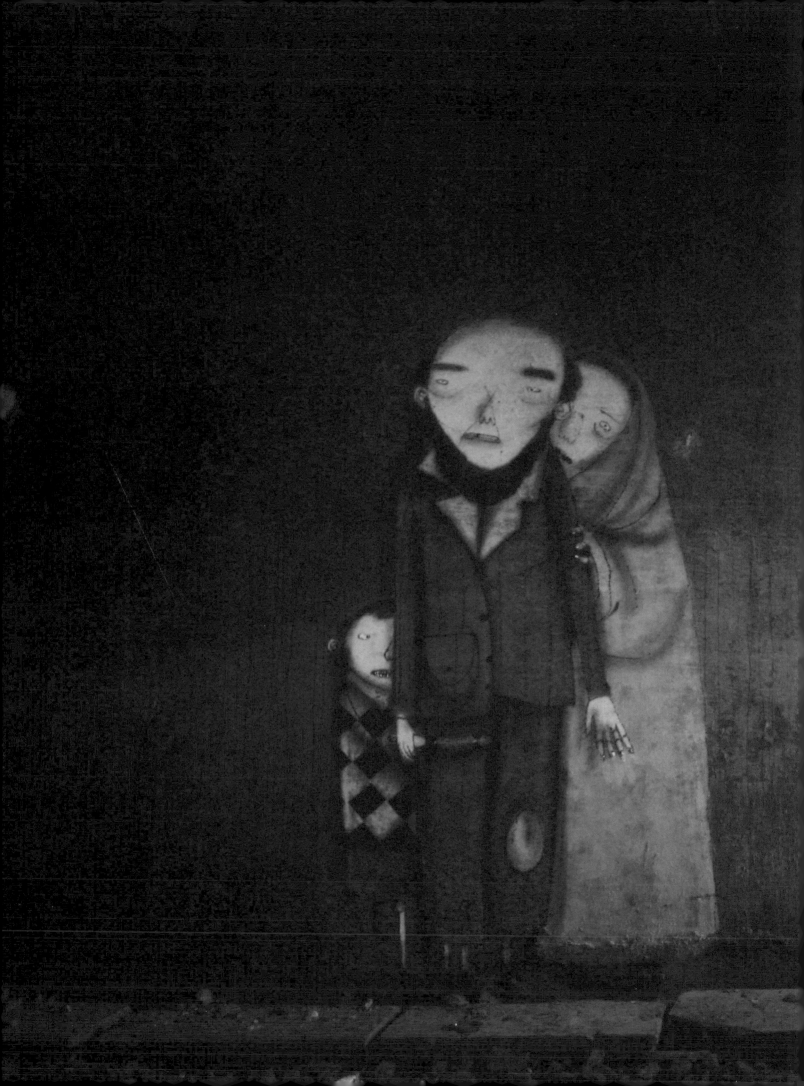

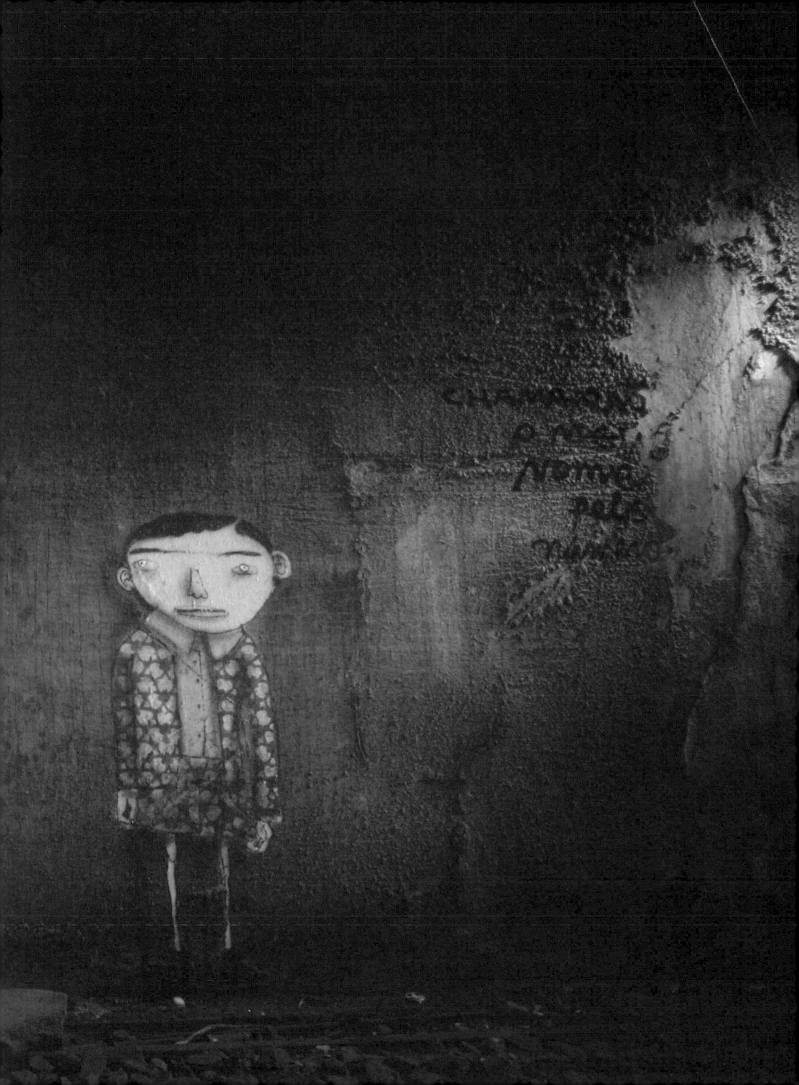

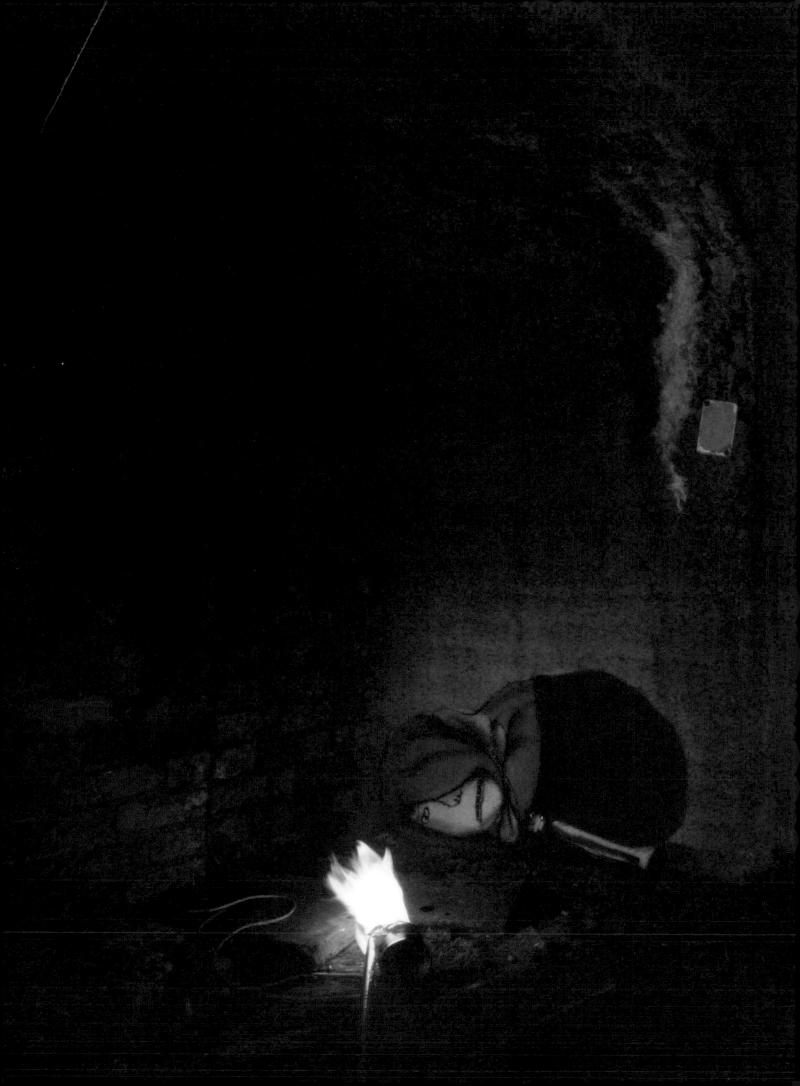

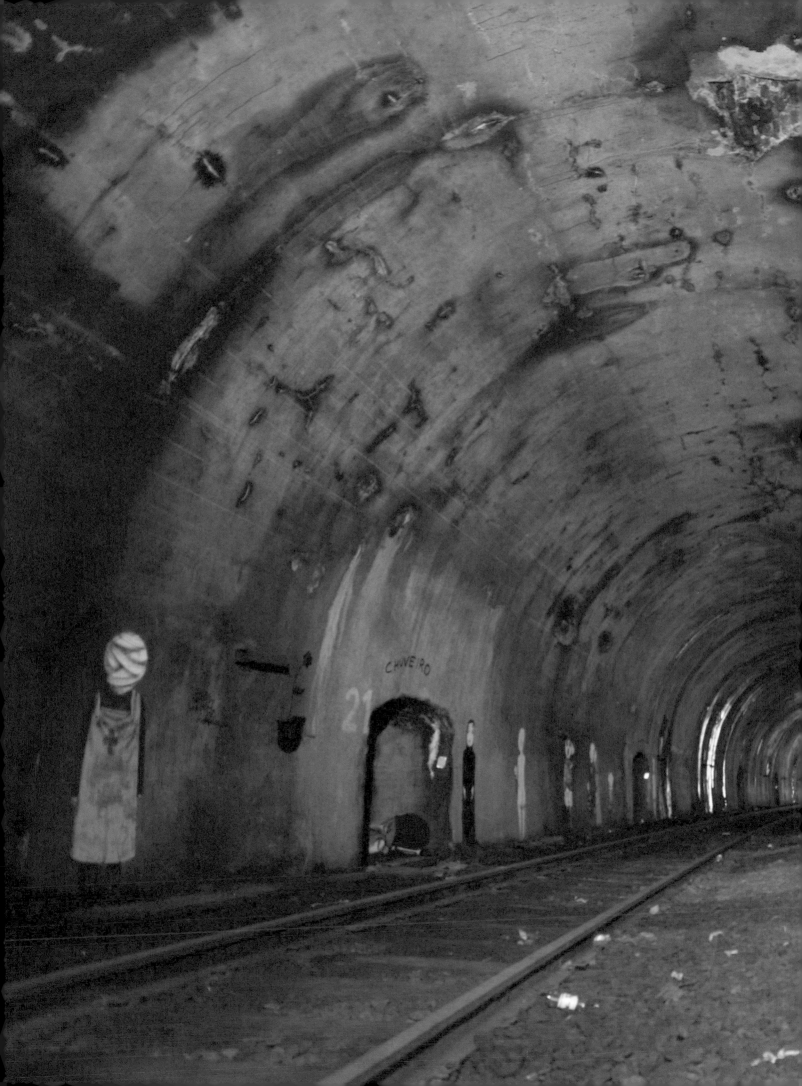

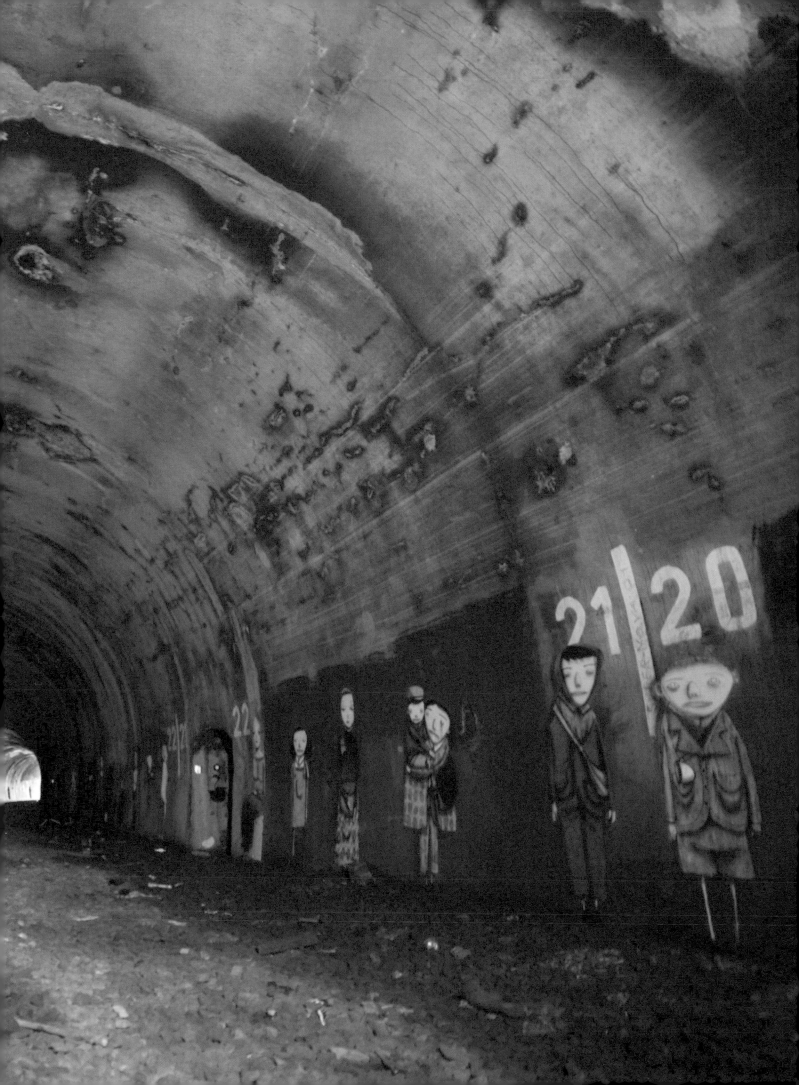

# NIXFITTI
## RICHARD SCHWARZ, RAINER MACHER, SPITBOY, RELAX, ROGER

Nixfitti is a project by a graffiti writer collective from Berlin. They got together in Wuppertal to remove graffiti from an entire block of apartments in the city center.

The whole graffiti writing culture lays great emphasis on independence from institutions and commercial interests.

Does it work then, as a graffiti writer, to cooperate with a large company in a guerilla marketing art project? Or do you make yourself untrustworthy?

We founded Nixfitti in order to showcase a critical statement by accepting the cooperation, but completely reversing our working methods.

By making this statement, we opened up the discussion about this subject to a broader public and, at the same time, provoked a debate within the graffiti scene.

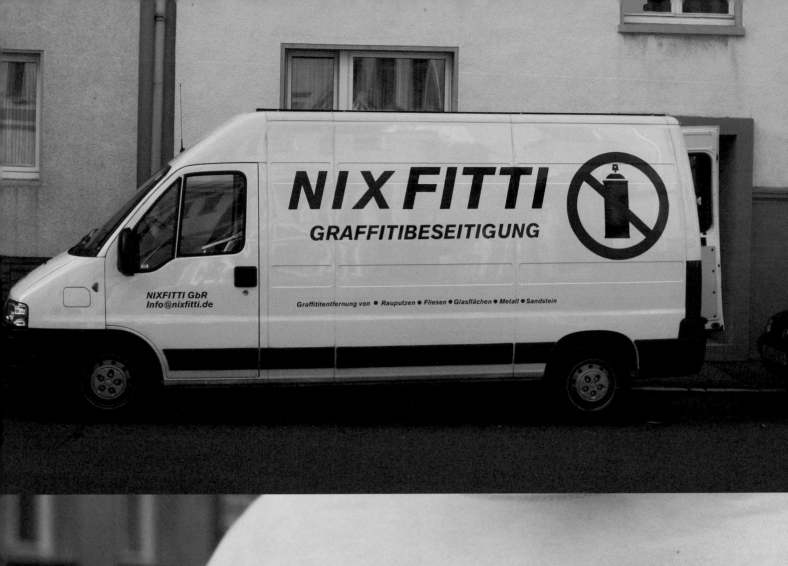

**NIX FITTI**

GRAFFITIBESEITIGUNG

NIXFITTI GbR
Info@nixfitti.de

Graffitientfernung von ● Rauputzen ● Fliesen ● Glasflächen ● Metall ● Sandstein

**NIXFITTI**

GRAFFITIBESEITIGUNG

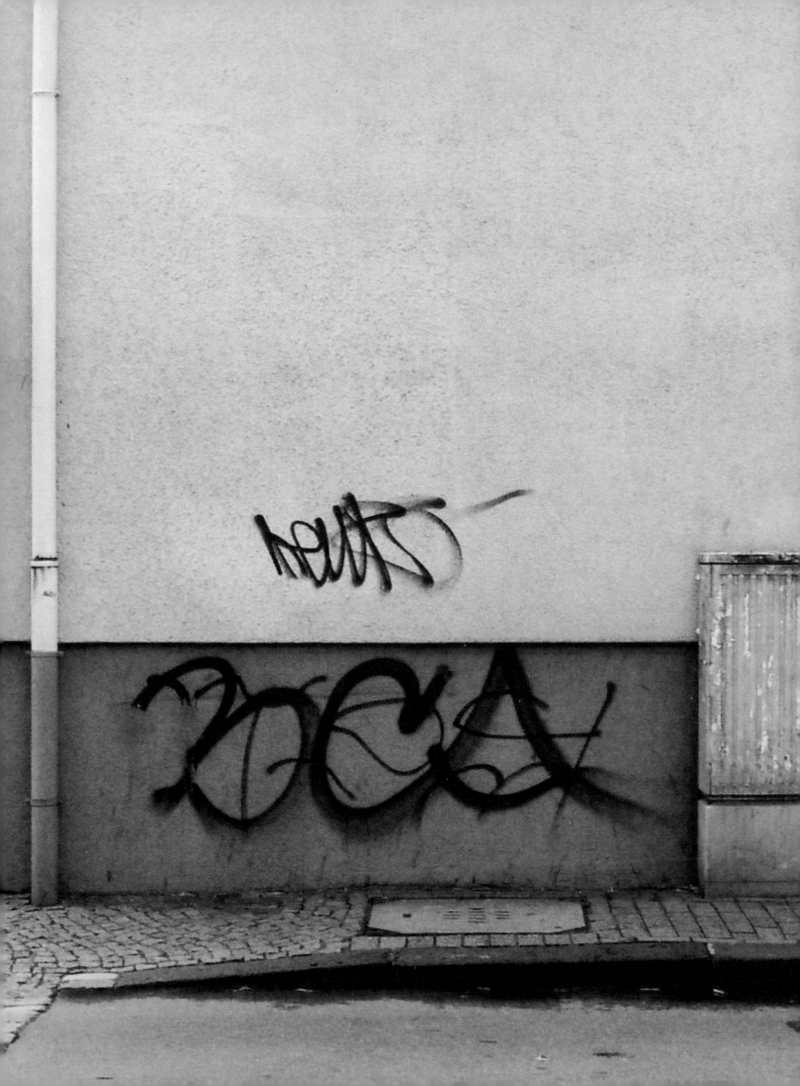

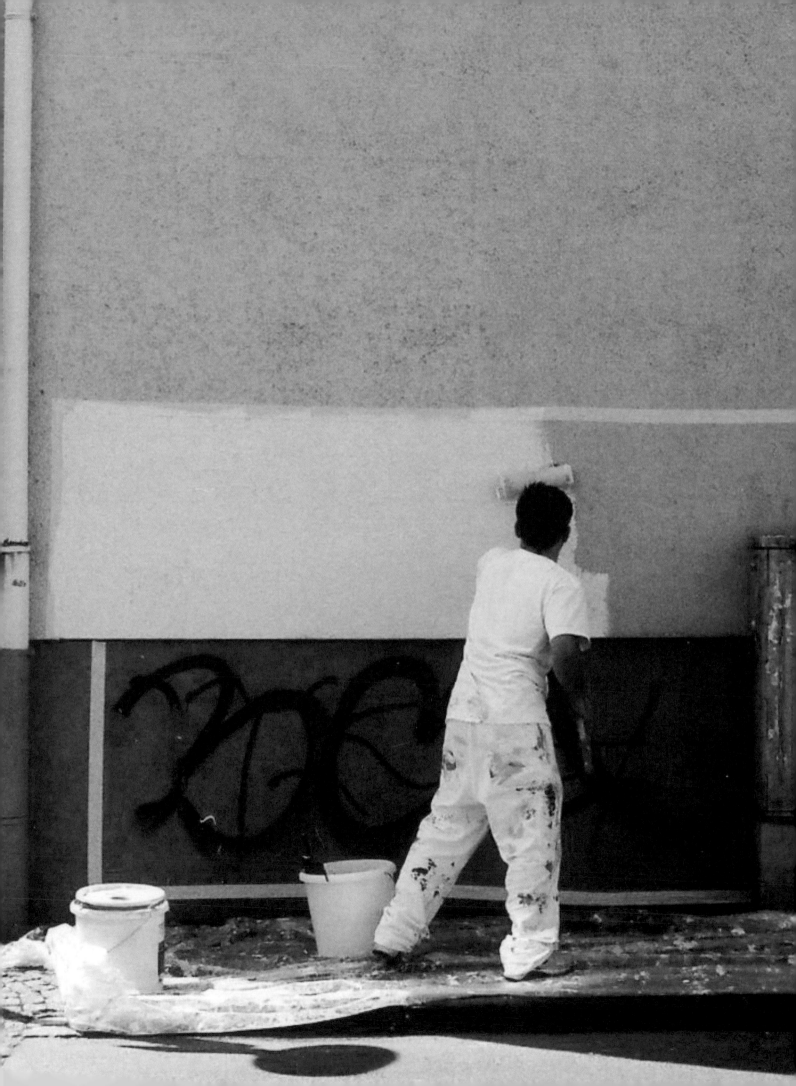

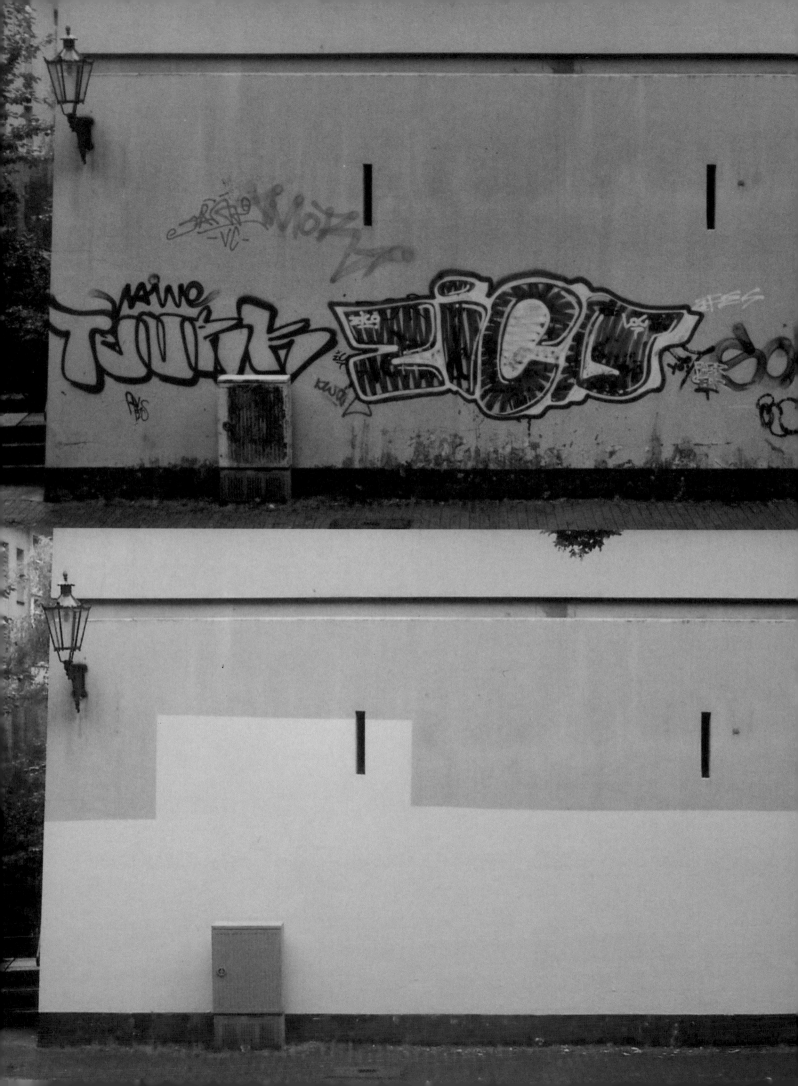

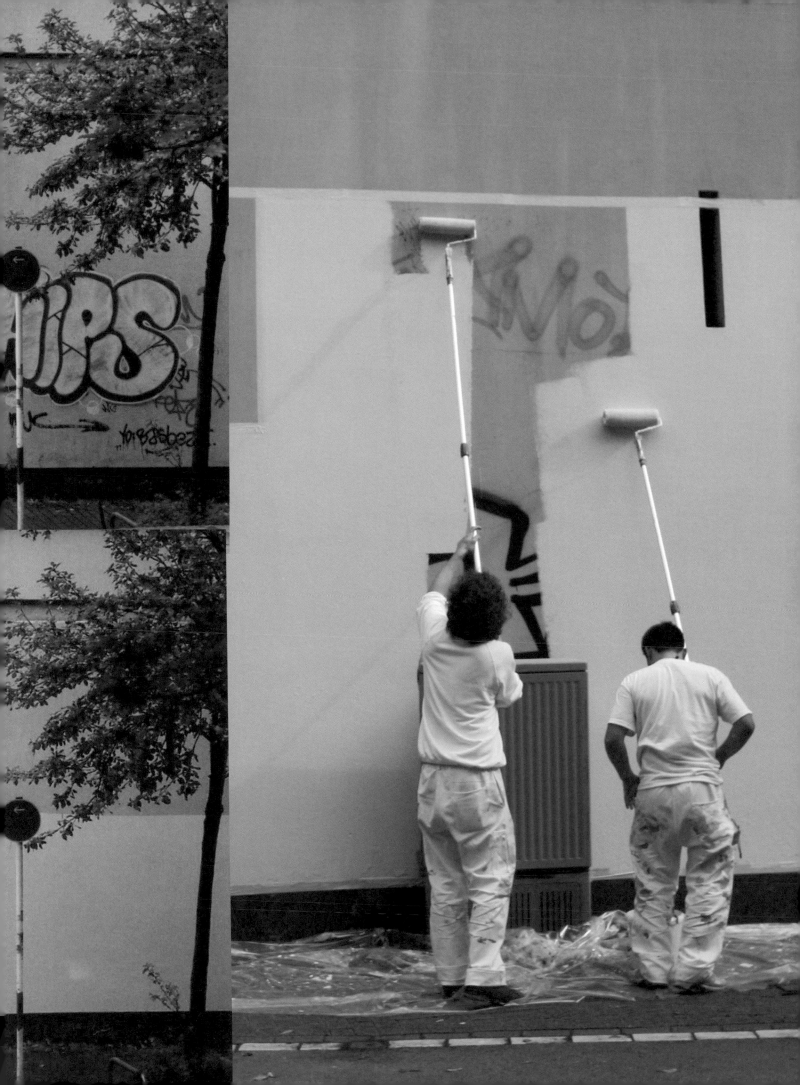

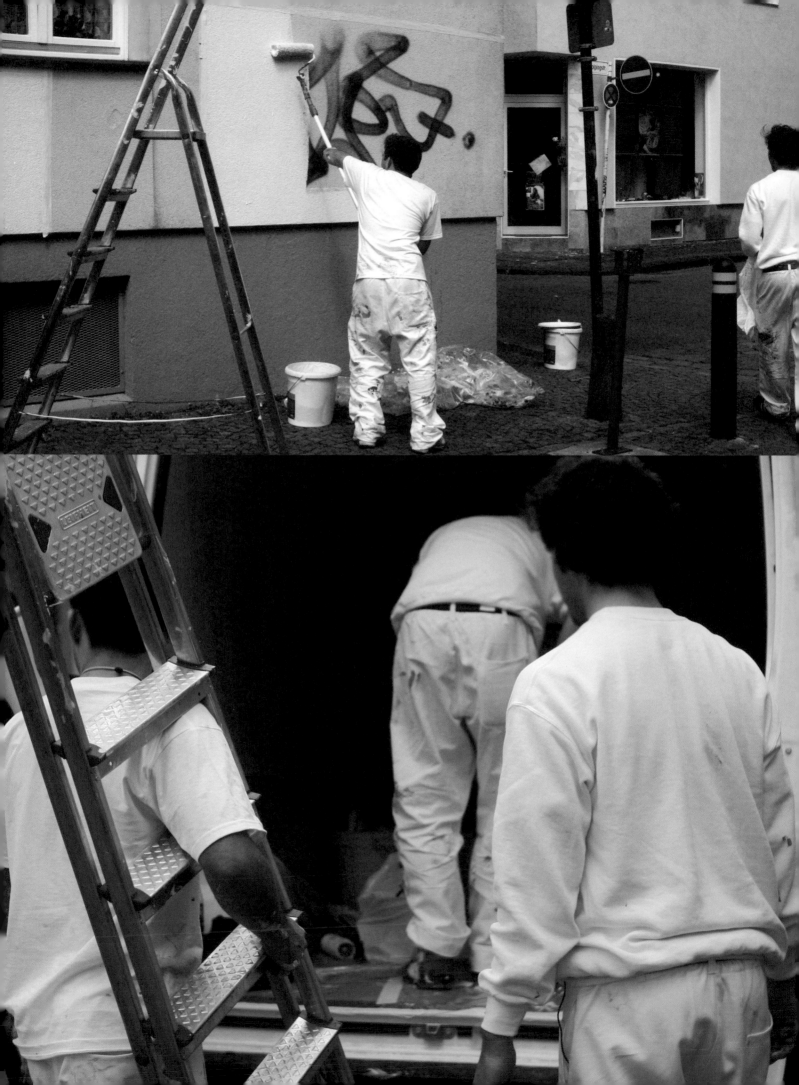

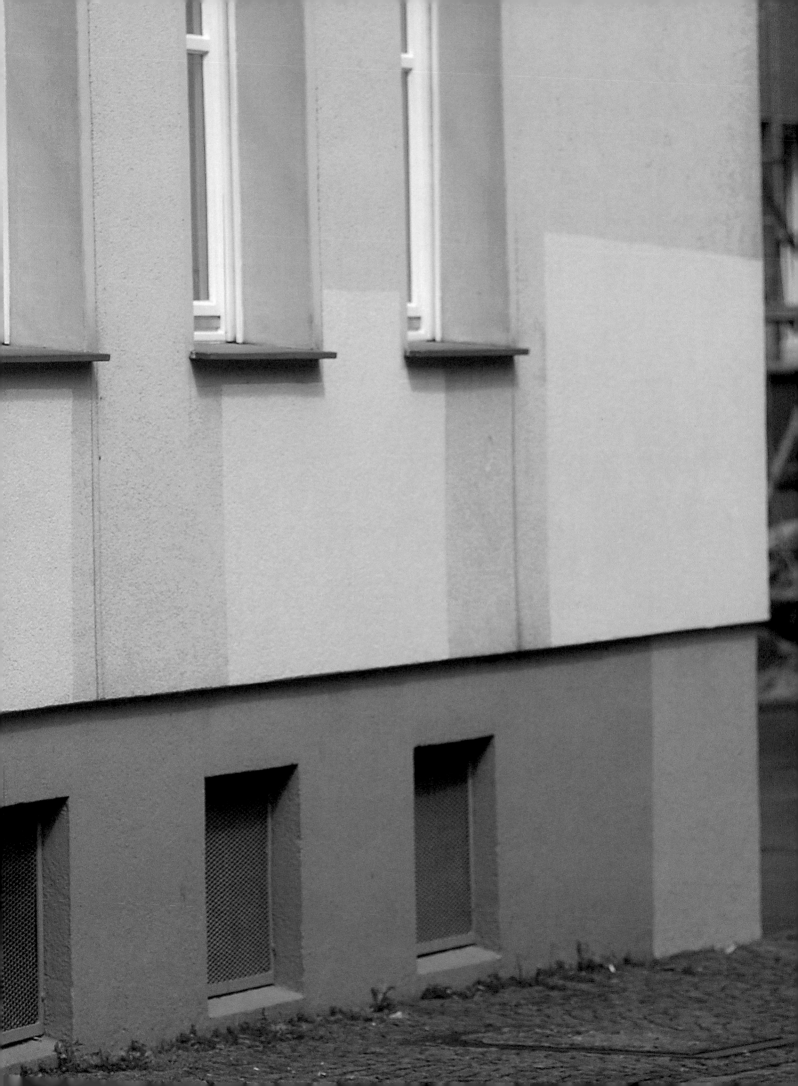

# DESIGN YOUR LIFE
## MR. HORSE

Mr. Horse is from Austria and, as an innovative graffiti artist, has earned a reputation that reaches far across the Alpine borders. One of his recurring motives is a stylized horse. He has transferred this horse onto many different formats and has even given it product character as a self-assembly toy. In Wuppertal, this trained architect closely observed the city and its structure. His horses (32 altogether) appeared as wooden sculptures in various locations throughout the city. Every horse has its own story which can be discovered by looking at its characteristic features. Throughout the city, Mr. Horse also handed out little booklets in which each horse's story is told.

*Project description:*

Nine wooden horses and 23 smaller ones were put up in different public places.

*What was the idea behind your project?*

To tell people that it's up to them how their life looks, and that it's up to them to make new decisions or to stay as they are.

*How did you develop your project?*

By watching the city, finding potential spots to play with, coming up with the main idea and then bringing it into its final form.

*Why did you decide to be part of the project?*

I don't say no to "Kunstmäzen" (patrons of the arts), and the people who asked me to take part in it had the right background and attitude, so there were no concerns for me.

*What was special about the project?*

That money was no problem.

*What do you think of Wuppertal as a location for this kind of exhibition?*

It's a good location, because it offers a variety of urban atmospheres and the characteristic "Wupper" and "Schwebebahn".

*How much was your project affected by Wuppertal?*

Not so much.

*Do you think the frame of OUTSIDES can be a role model for further projects?*

Yes.

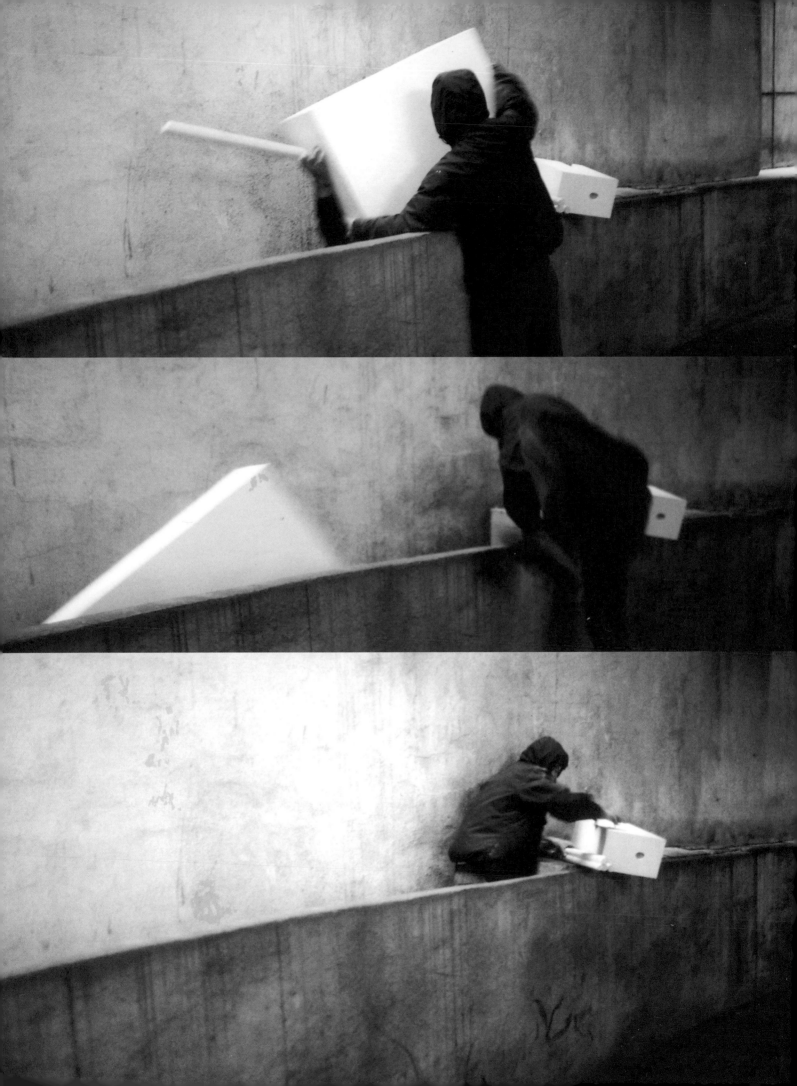

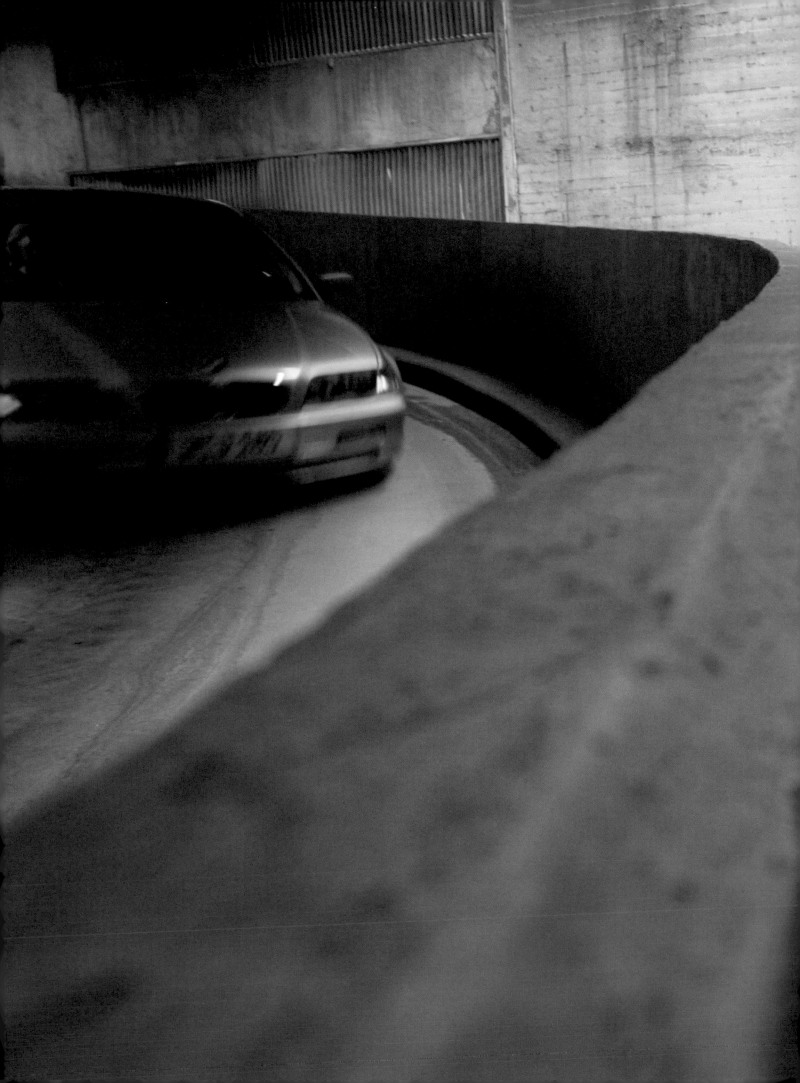

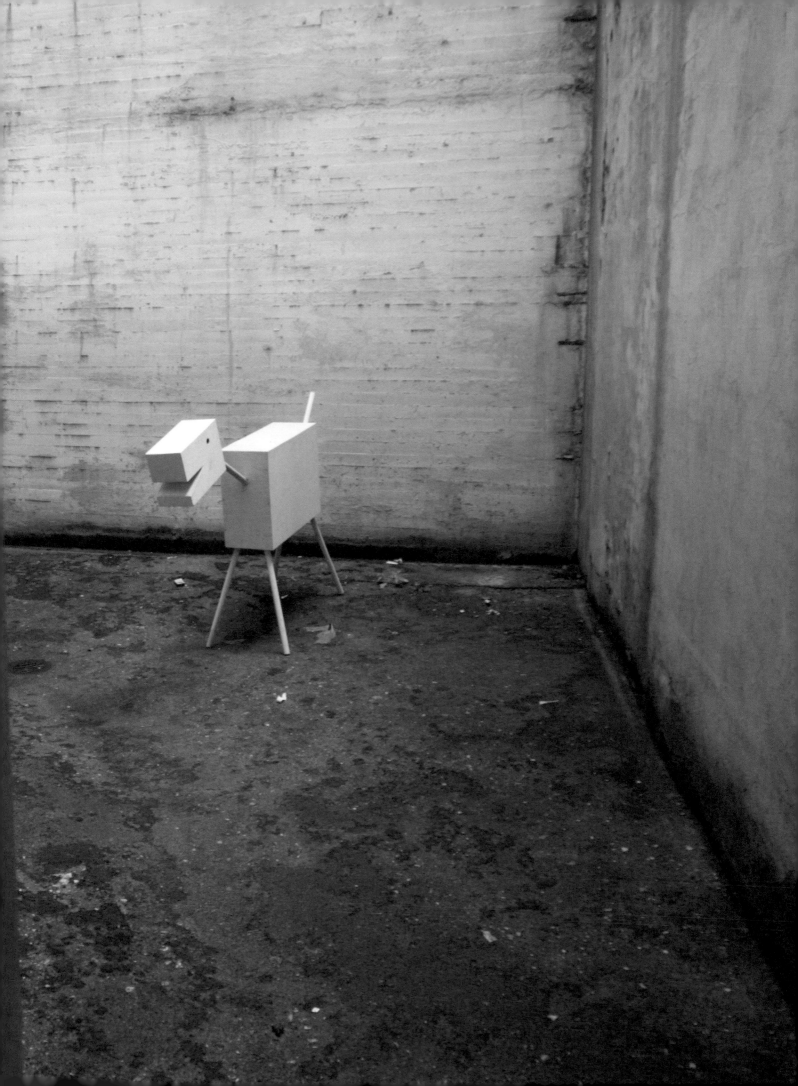

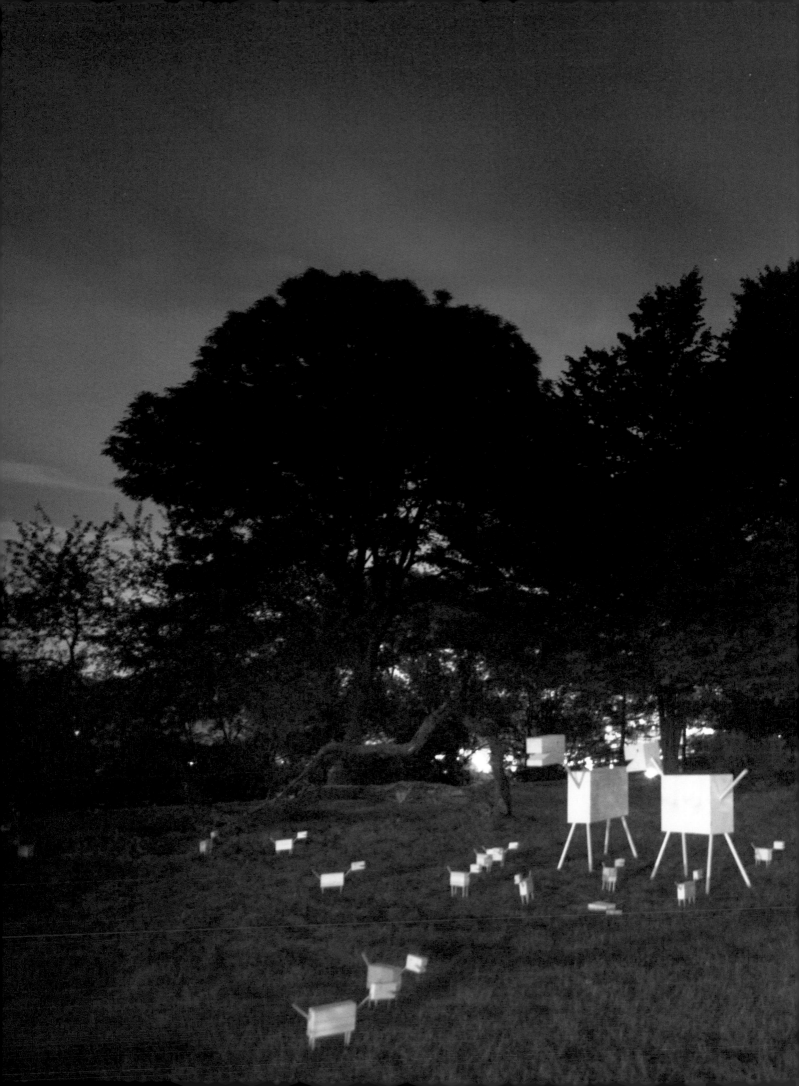

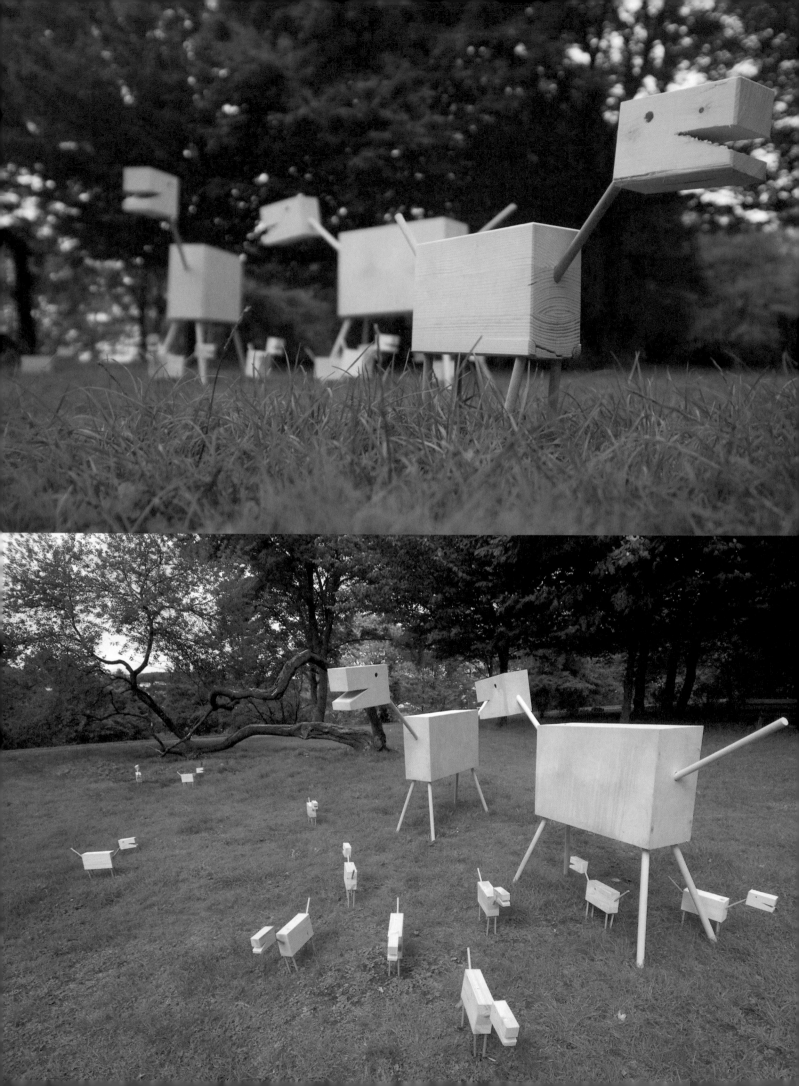

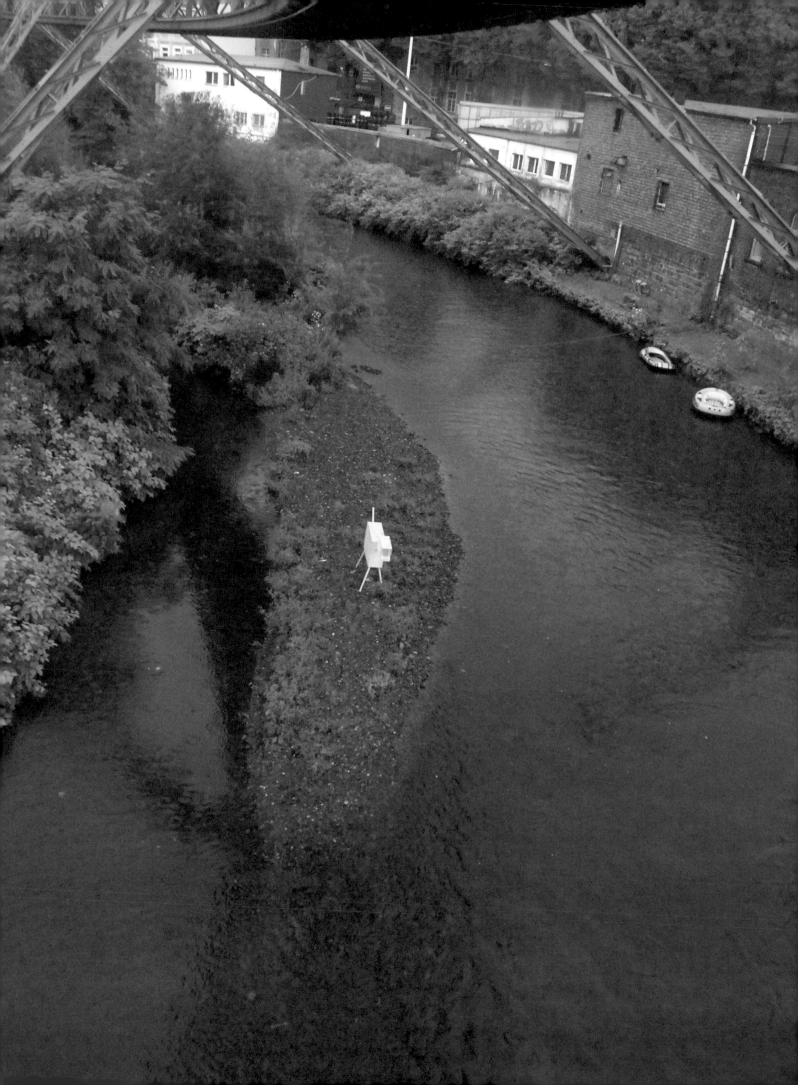

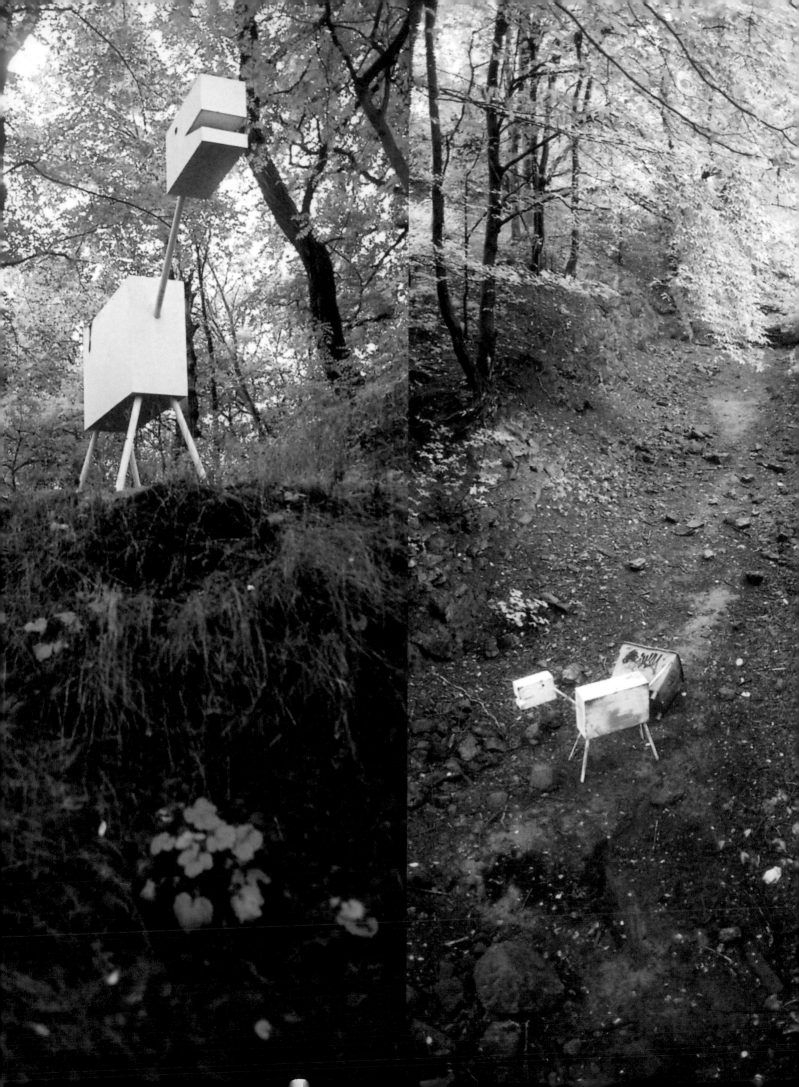

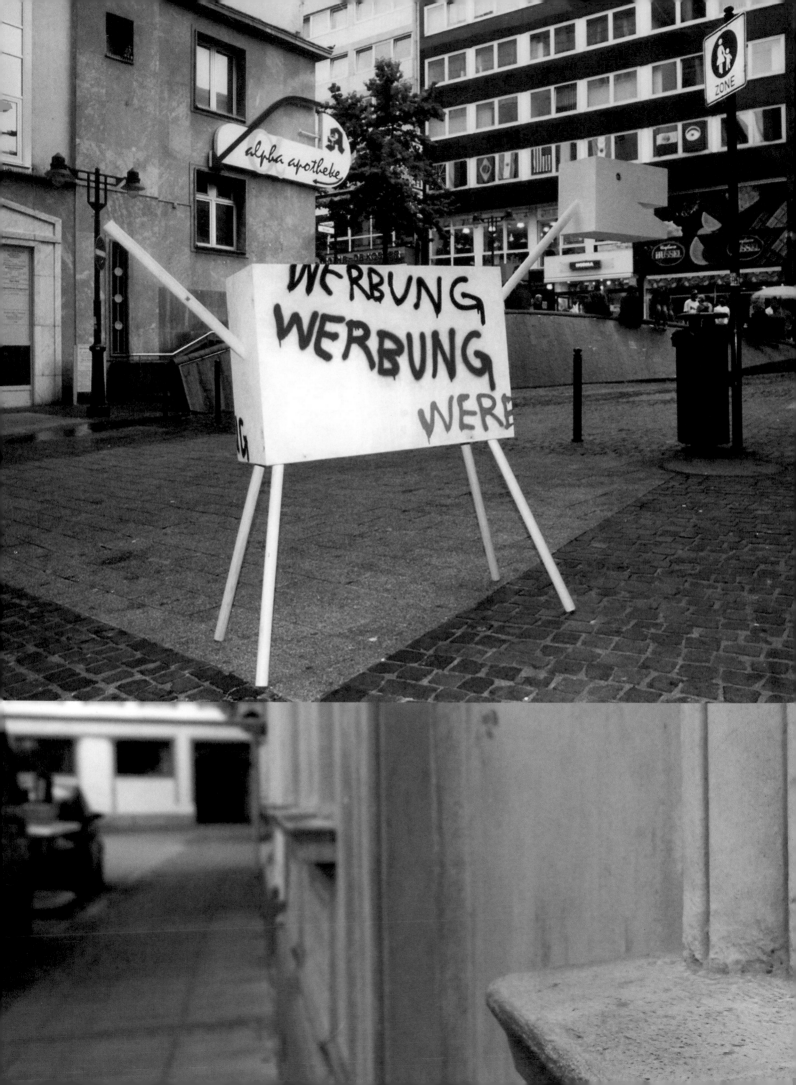

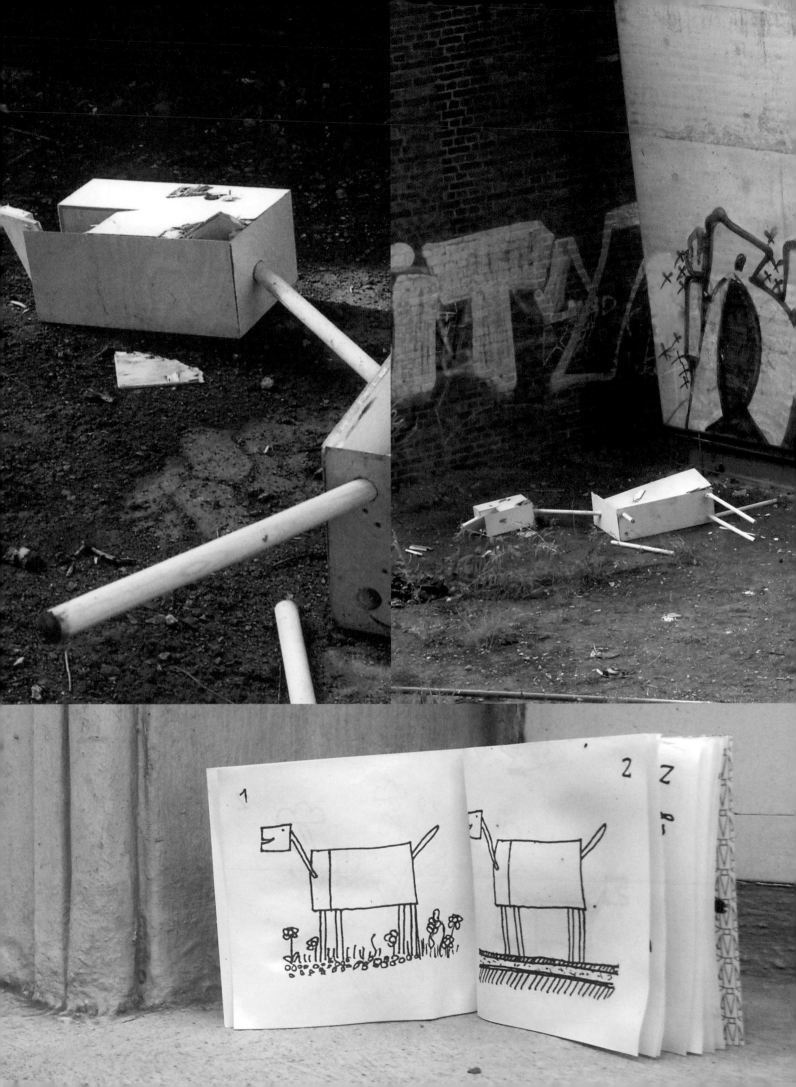

# WU-STYLEWRITER
## MARE 139

Mare 139 is still known to many graffiti aficionados because of the legendary Style Wars documentary. He originates from the golden era of the New York graffiti movement and has kept up the dynamics of that era until today. Mare 139 still intensively deals with the expression of form in graffiti pieces and also their relationship with the expression of B-Boy moves. He also translates his observations into sculptures. In Wuppertal he looked for a place where the strength of his sculptures would be able to come across best. With the podium in Deweerthscher Garten he found a place which, with its active and calm components, provided an ideal surrounding for his work.

*Project description:*

The goal was to successfully place a sculpture in Deweerthscher Park as a presentation to the city. The strategic placement was a critical factor, as it was to be in an accessible environment where citizens could interact with it. Once in position, the documentation of the sculpture's life in public would begin. The sculpture was inspired by the city's Monorail and landscape, the way it weaves through the valley in a swift and fluid motion.

*What's the idea behind your project?*

The idea behind the creation of the WU-Style-Writer was to interpret my impression of the city, yet keep the energy and character of graffiti style writing. Placing it in public unexpectedly would provoke a dialogue about where it came from and whether such a refined piece of work was placed by the city or was an act of vandalism.

*How did you develop your project?*

The project was developed through my visits to Wuppertal and the discovery of the public park, Deweerthscher Garten. On a scouting mission, my associate producer introduced me to the place. That day a snow blizzard was enveloping Wup-

pertal. We discovered the circular stage which was covered in snow and I began to draw on top of it. I walked around it and looked at it from all distances and angles in order to consider the environment in which a sculpture could exist. Once I had photographed the location, I studied it and thought about what the sculpture could be. When I had created the sculpture study, I photographed that and made a computer montage of what it would look like. The study was then shipped to the fabricator with size and material specifications. He then proceeded to fabricate a larger study first, followed by a fully realized version. Upon arrival in Wuppertal, I again reviewed the sculpture's progress and was impressed with how well it was executed and articulated from my model. Once we had discussed the final steps of fabrication I would not see it again until it was completed some weeks later and prepared for installation. When I saw the final version I was pleased and felt that it would make an impression on those who viewed it.

*Why did you decide to be part of the project?*

There are many factors as to why I got involved. The opportunity to realize a large sculpture was hard to pass up, but to a larger extent the op-

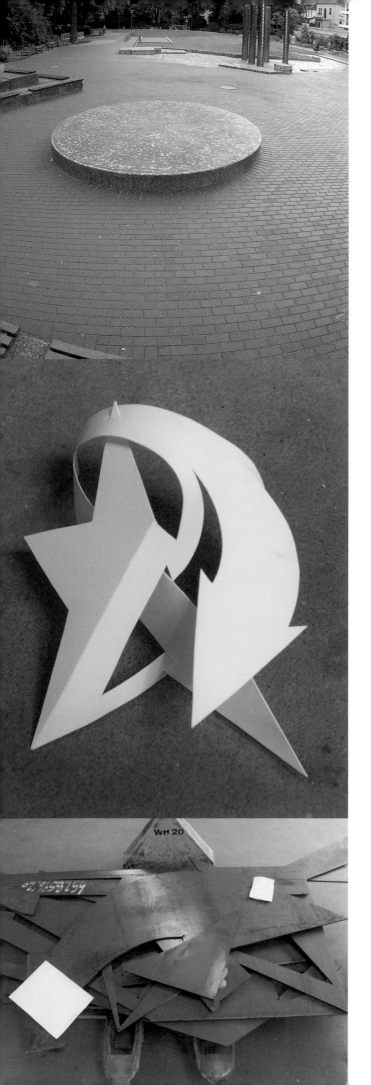

portunity to take part in an art event that would have social and historical implications was just as important. To be part of an illegitimate collective was reminiscent of my days of painting subways in the 70s and 80s in NYC. I was drawn to the idea of meeting artists from all over the globe who shared the concept of creating unauthorized public art for the city of Wuppertal. The city itself also provided me with the concept for a work that I felt had to be made. Once it was conceived I was committed to it. Another important reason to be part of the project was driven by ego - to be able to represent the best art from New York City was a factor. For the genre of art we all share in there is a competitive nature that drives our creativity, especially for style writers like myself. To have the opportunity to bring an innovative and progressive sculpture to Germany was important, as I knew it would have great influence on the street culture once discovered.

*What was special about the project?*

It was, without hesitation, the collaborative effort to realize such an ambitious project - from the management and support teams to the artists and sponsor. Collectively, all these things presented very unique issues that provoked intense dialogue about how and why we were going to do this project. For me, the most rewarding experience was having long and continuous conversations with the younger artists - ambitious discussions about art, history, culture and purpose. We were all very much caught up in the moment, sharing our ideas, our art history and exchanging important information about those whose legacy we continue through our art. Although New York City created Contemporary Street Art and Culture, our influence has given birth to a whole new generation of artists globally who practice and innovate on what we started. For me personally it was the education of the world at large which shared in a common interest. Concerning the hideout - imagine living in a really special house, one that was created in the

most artistic spirit by an art historian, a home that had many rooms but no sharp corners - nothing but fluid curving architecture, and was tucked away in a forest setting. Imagine that and then imagine being surrounded by young artists, photographers, film makers and art critics from all across the globe. How was this possible? Why even do such a thing? Personally, it reminded me of the early 1900's in old Europe. Then, artists and writers also came from all over the globe to share ideas and shape the new world. But this time it was a gathering to shape popular opinion, to evoke a dialogue with the public about what legitimate art is. Now consider that it was a sponsored event, by a corporation no less. This was a heated and contentious issue, in which I participated. Two very well-respected artists addressed it best. They were from Berlin and were concerned with the branding of such an event and how the branding would effect the overall perception of the project, not to mention their own standing in the community. The issues of artist rights, compensation, corporate identity etc. - all were dealt with and the conclusion was that the artists had a very strong position. On the other hand, the sponsor's representative also had a position to hold and was firm on it - sympathetic to the artist yet loyal to his brand.

*What do you think of Wuppertal as a location for this kind of exhibition?*

Wuppertal was the perfect city for this exhibition, in my opinion. It has a very beautiful landscape and is very diverse with its urban, suburban and valley areas. It is a lot of things at once and yet it is still  a sleepy little town with a rich history in the arts. The monorail provides the immediate point of interest, but once you travel around a bit you can see how beautiful the city actually is. One of the things I enjoyed as I followed the art installations is that it allowed me to see more of Wuppertal. Since it is a small, quiet city, our installations had the chance to be noticed. In the end it proved

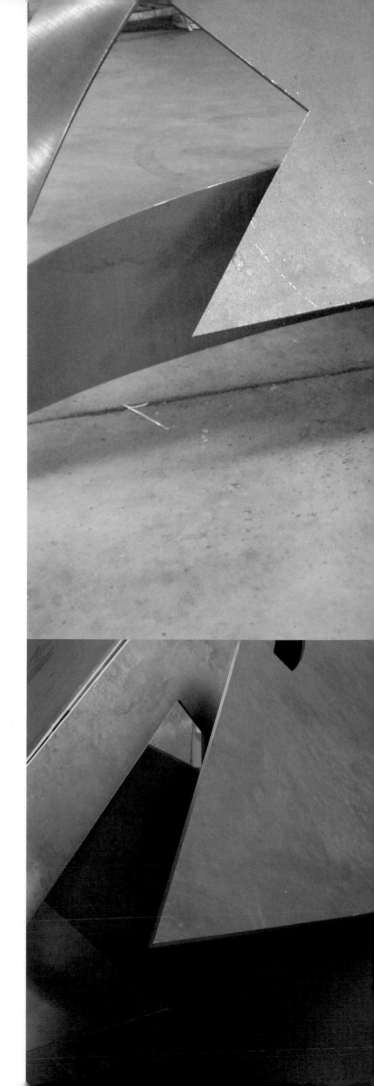

to be a successful choice for the project.

*How much was your project affected by Wuppertal?*

I think it's more like I had an effect on Wuppertal. One of the best and most moving moments was the installation of the work at the Deweerthsche Garten, but even more special was returning that afternoon, with the intention of photographing it, only to see children playing on it, climbing on it, and generally exploring it. I had no idea it would find such an inquisitive audience in children. It was awesome. There was one boy who threw his ball off of it and a girl who took refuge in it, thereby creating her own art. The best was a 16 year old boy who rode around it on his bike, parked the bike, climbed onto it and sat down with an air of authority that said that this was his throne from where he could observe all the other kids in the park. Adults too were taken in by the work. They would stop to examine it and I could see how the shapes of the sculpture made their bodies move as they observed and followed its arcs and lines. One woman felt it had really caught the character of the way Wuppertal moves. In the end the city council discovered it, felt it was too dangerous to leave in public and made plans to remove it.

*Do you think the frame of OUTSIDES can be a role model for further projects?*

Yes. I can see this reaching out to many parts of the world and to many different artists. It's a calculated risk, but risking nothing is offering nothing and what is better to give a city than art?

*www.mare139.com, www.stylewars.com*

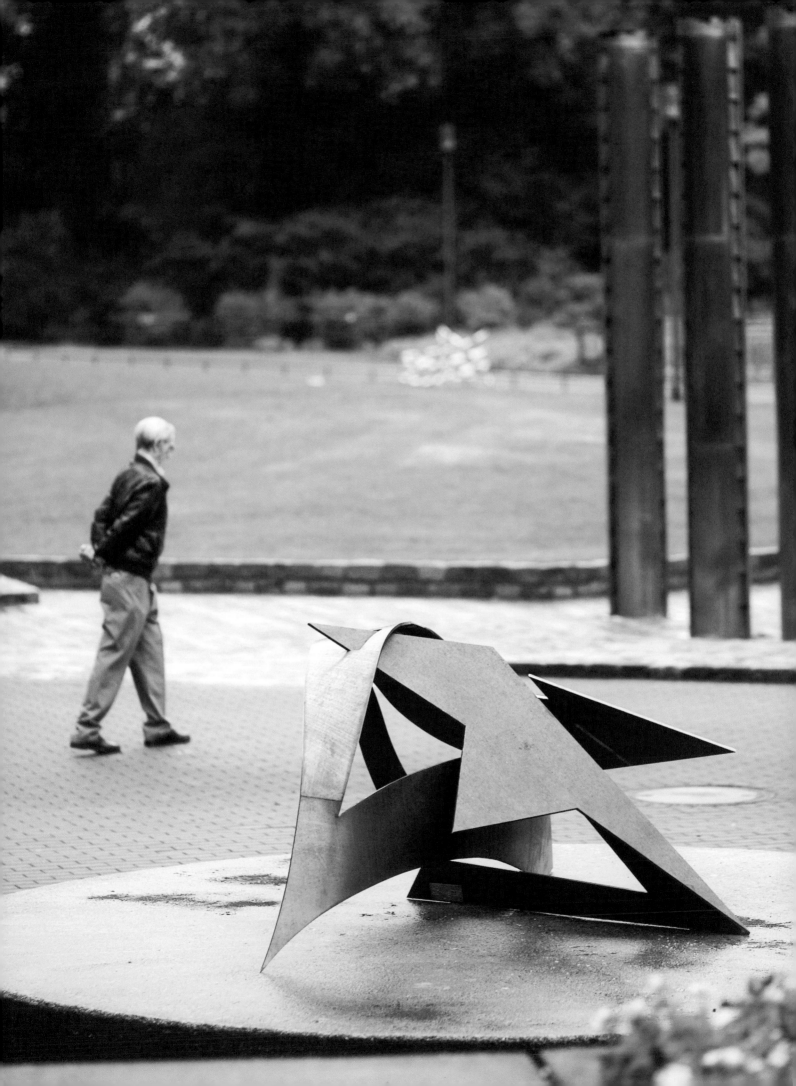

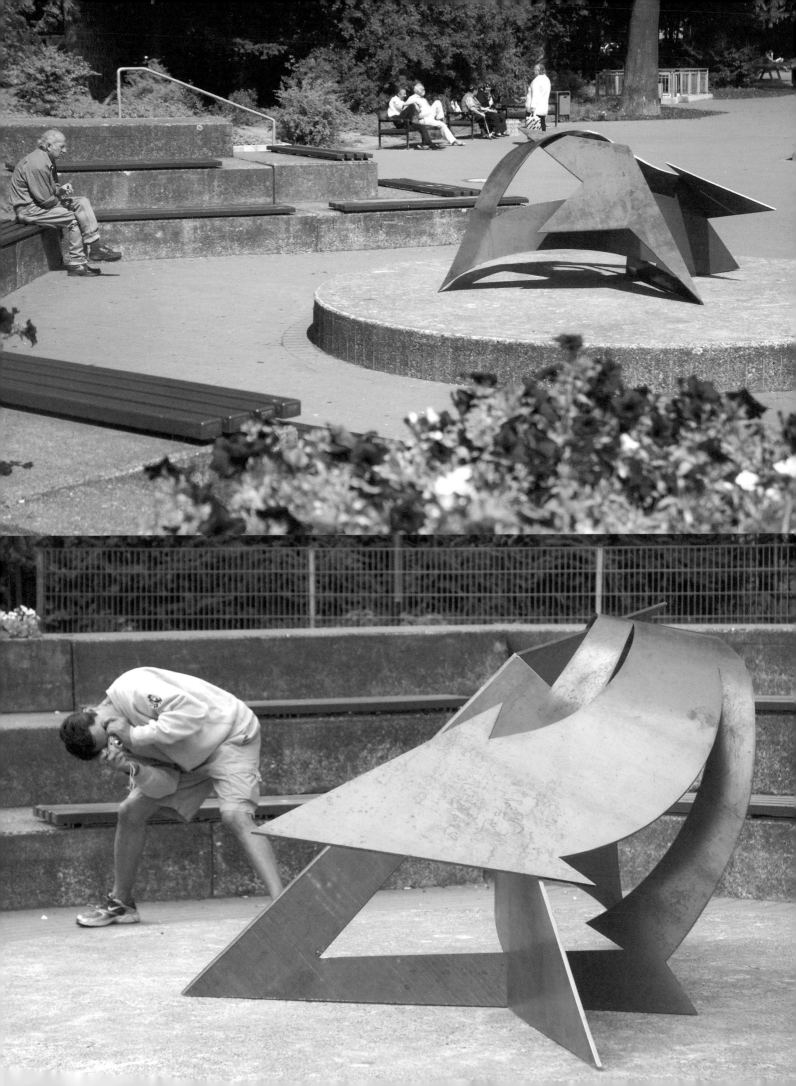

# NATURAL REACTION
## HITOTZUKI (KAMI & SASU)

The Japanese artist duo Hitotzuki is known world-wide for the pair's unique productions at exhibitions and their live performances. Kami & Sasu create many pieces together and their aesthetics and expressions of form combine with a special kind of harmony. They let themselves be influenced by the impressions and dynamics of their environment. In Wuppertal, they chose a disused railway tunnel for their work and injected some life into the forgotten ruin by giving it a new expression and function.

*What was the idea behind your project?*

We wanted to see how a mural painting could affect a place which had fallen into ruin. We wanted to make the space alive with our painting which reflects our power, spirit and soul. We usually paint improvisatorially, based on what the place inspires in us. Our work on this project was experimental work and we were influenced not only by the tunnel, but by the whole environment of the city, Wuppertal.

*How did you develop your project?*

First of all, we checked the place out. Then we decided on a rough framework and motif based on our inspiration from the space. We lit a fire before starting our work as a sign of appreciation for the wall and the place, and we wished for the success of the project. We built entire shapes according to the layers that follow one after another. Sasu began by drawing the character "kumosha", who brings a light into the darkness. Then Kami's line became "tiger", which is our Chinese sign and which is supposed to reflect our Asian spirit. Then each character developed into a spacecraft, which took the shape of a tiger's body. The inspiration from children became cats and flowers. The image of wind blowing into the tunnel was then completed along with the motif of the cloud, painted by Kami, which extended across the whole painting. The outlook described is the world of two becomes one. It tells the story of a spaceship, carrying various

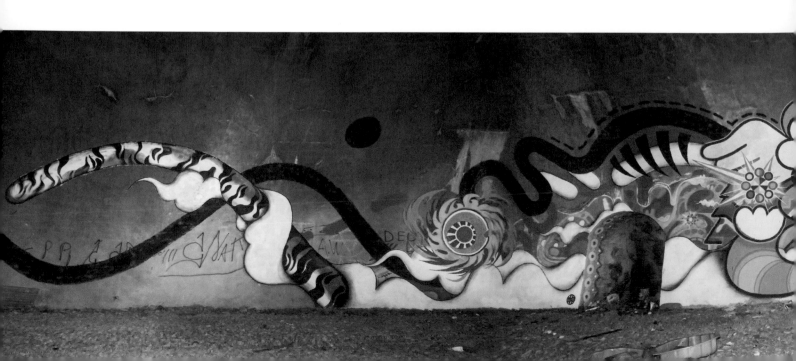

spirits, flying in from Japan. Sasu then decorated the rubbish which soon became the waste at the hole in the wall. Lastly, the wheels of the spaceship, the centre of the whole motif, were completed. When the mural was finished we lit 108 candles so that all our negative energies would be burnt there. We had then completed all necessary stages. One fantastic moment came during an unexpected thunderstorm, when the sound of a big thunderbolt echoed and passed through the tunnel.

*Why did you decide to be part of the project?*

We were delighted to exchange and communicate with the other artists about this project. Apart from that, this project was one which could be expressed the way we wanted to express it. Also, the location for the expression (of our project) is not just a gallery or museum - it is a place of interest in itself.

*What was special about the project?*

The exchange with other artists was very stimulating. Homemade dishes, prepared by staff and artists, the house where we stayed…. It was like a secret artists' meeting.

*What do you think of Wuppertal as a location for this kind of exhibition?*

Ideal. Unlike a city which is filled with a lot of information.

*www.hitotzuki.com*

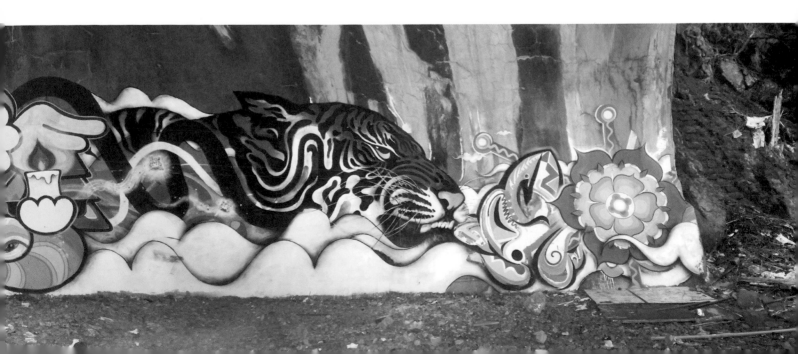

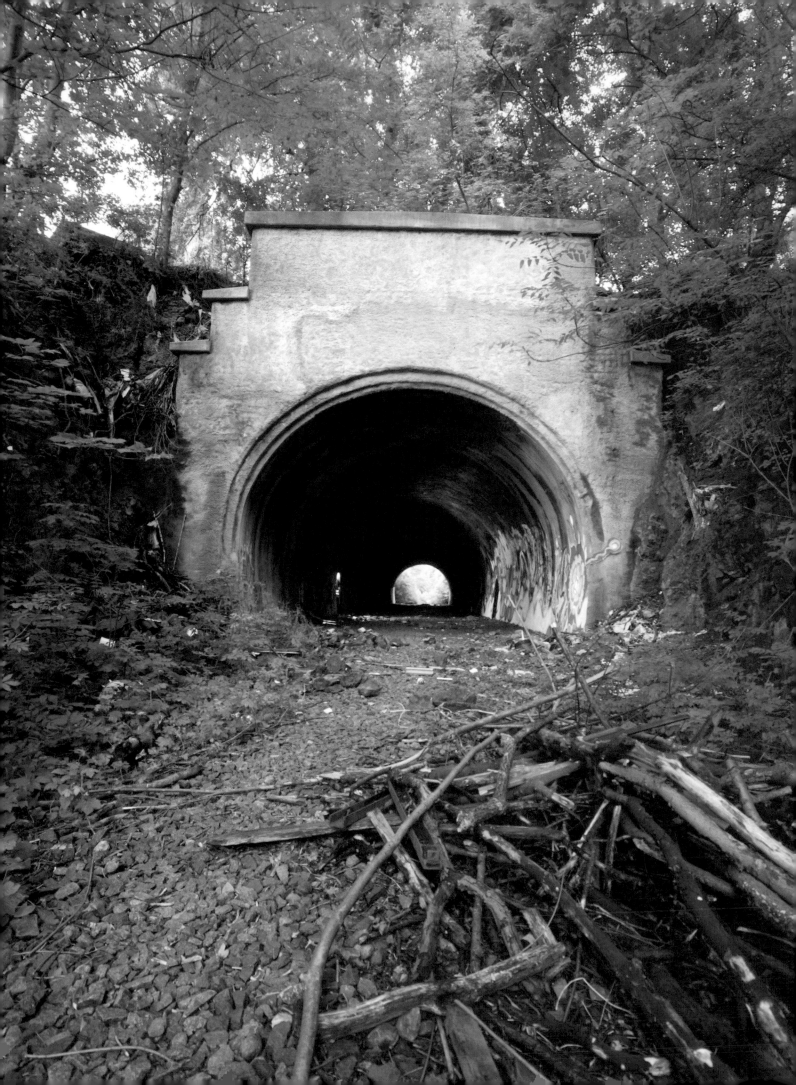

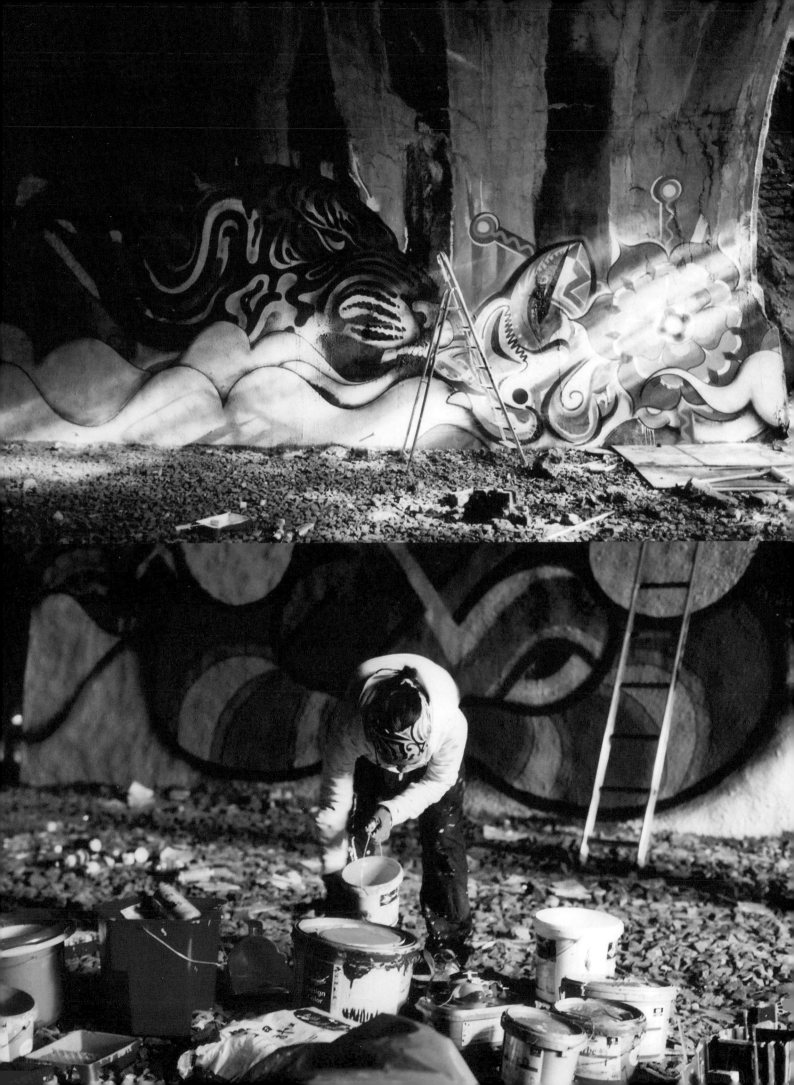

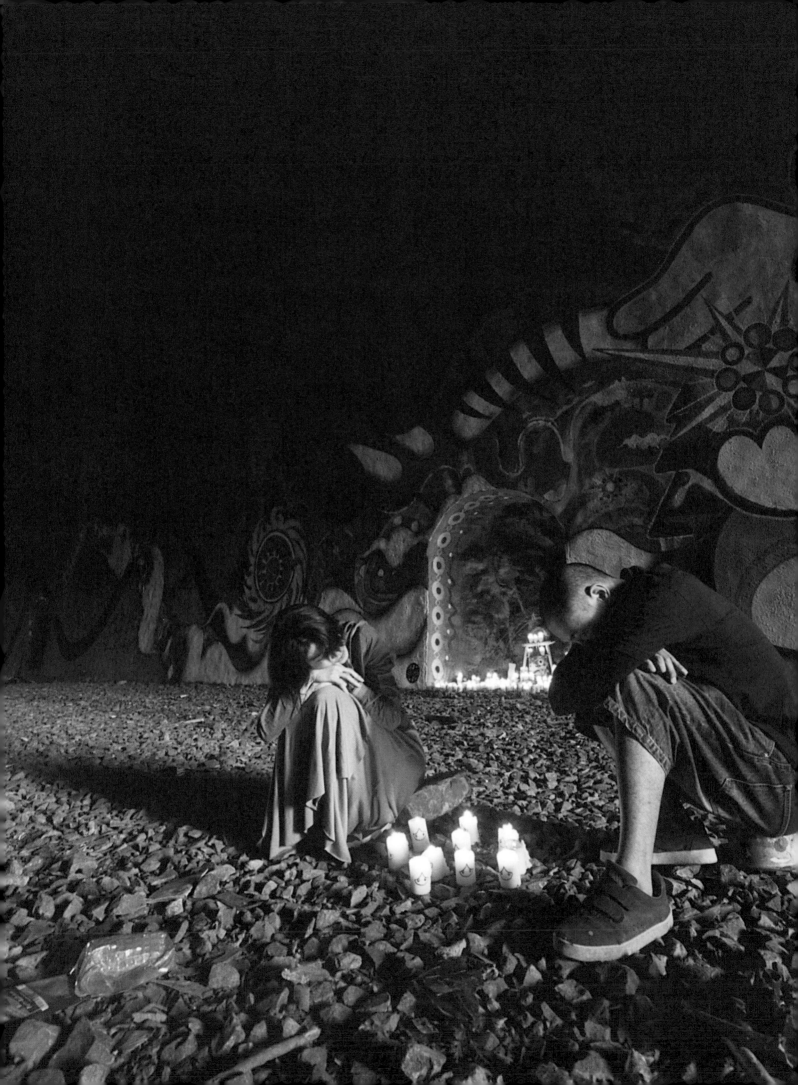

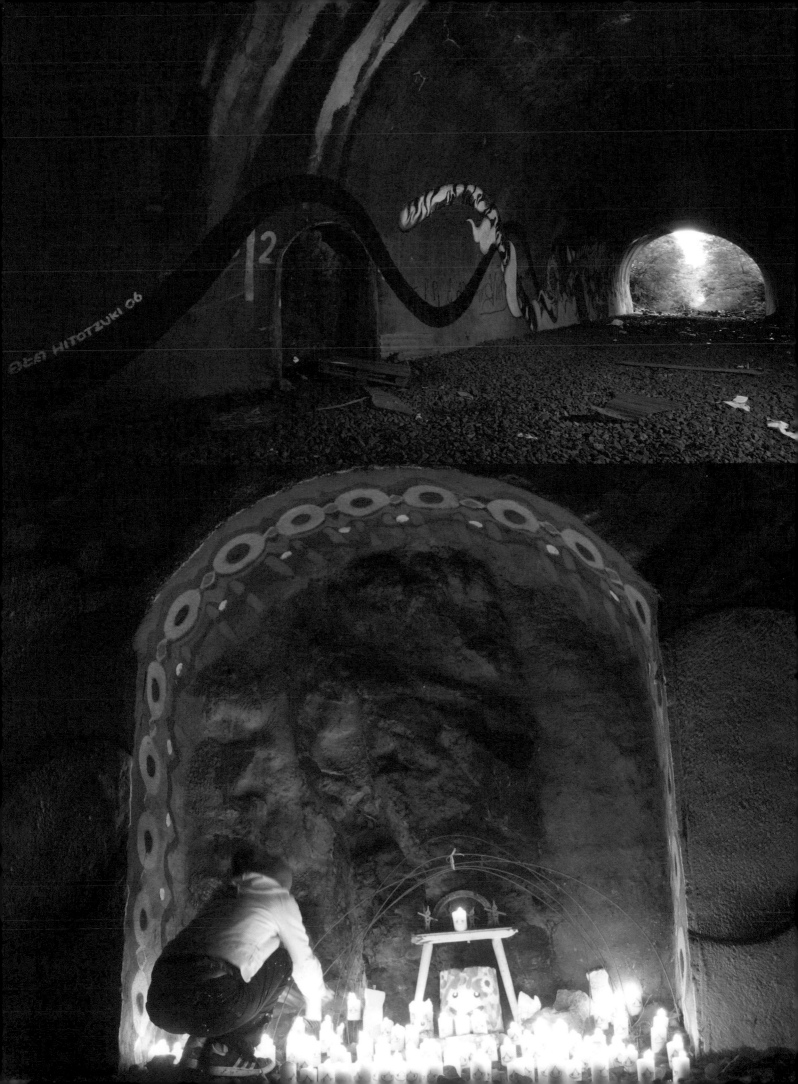

# JR - IS WATCHING YOU
## JR

The Parisian artist JR works with portrait photos which he puts up on walls, bridge pillars or gates. Through the special aesthetics of his photos and the sometimes gigantic formats in which he brings the faces to the city, he directly challenges advertisement posters and gigantic banners in a visual way. JR spent a whole week in Wuppertal portraiting people without them knowing it. He decided to exhibit these pictures at one of the most central places in Wuppertal - the teleferic. He worked with different kinds of formats and material - with posters, stickers and gigantic banners - and in this way gave the city a new face. JR's portraits along the teleferic polarized the people of Wuppertal and initiated extensive media coverage and public discussion.

*Project description:*

I took photos of the daily life reality of the people in the Schwebebahn (monorail) and pasted them along the train line illegally in large format. The people discovered black and white, large format photos all over the line with their faces and recognized themselves or their relatives.

*What was the idea behind your project?*

The idea was to use the advertising codes to show peoples' daily lives without any artificiality. I wanted them to discover the whole thing in the morning without knowing if it was legal or illegal. … The fact that it's a small city made the project much stronger. The main idea was the "starification" of regular people and how they reacted to it. There was also the idea that 'you are under surveillance' but that wasn't the main focus.

*How did you develop your project?*

I came to Wuppertal 3 times; first to observe, then I came for 10 days to take photos every day in the Schwebebahn. I know the line by heart now - I saw the same people many times during that week. That's something that rarely happens in big cities.

The selection was really hard because I wanted simple photos of people. I mainly chose photos where they were in the back of the train, at the window - as if they were in a bubble and I was outside of it, observing them. In some photos, people are looking into the camera lens - so they know that they are under surveillance, like on a regular video camera, but they keep on looking passively. The places where I posted the photos are very important. The fact that the photos were really big and unreachable made it look like advertising, people lost their bearings because they were not used to that kind of installation. I also placed stickers and smaller posters around to show that it was an invasion around them, that it was everywhere and that they couldn't control it.

*Why did you decide to be part of the project?*

I wanted to do something that I couldn't do on my own - like using a new form of exhibiting in the streets: hanging large-format photos. Being part of something strong, something that has never happened before, together with the strongest artists of today's scene, was decisive for me.

*What was special about the project?*

The "professional" organization of something completely illegal … brings it to another level.

*What do you think of Wuppertal as a location for this kind of exhibition?*

This industrial city is perfect for working in the streets and for photography. The train line is so original. This place is simply not fashionable, but benefits from national advertising campaigns of brands like C&A or H&M. When you look at those ads and then at the people, you have a really strong contrast.

*How much was your project affected by Wuppertal?*

I think that is apparent in the look of the people, mainly sad. Although maybe the weather plays a role there. … With the installation, the idea of hanging the banners and working with new material for street activism was really affected by the architecture.

*Do you think the frame of OUTSIDES can be a role model for further projects?*

OUTSIDES is done and was big … what's next?

*www.jr-art.net*

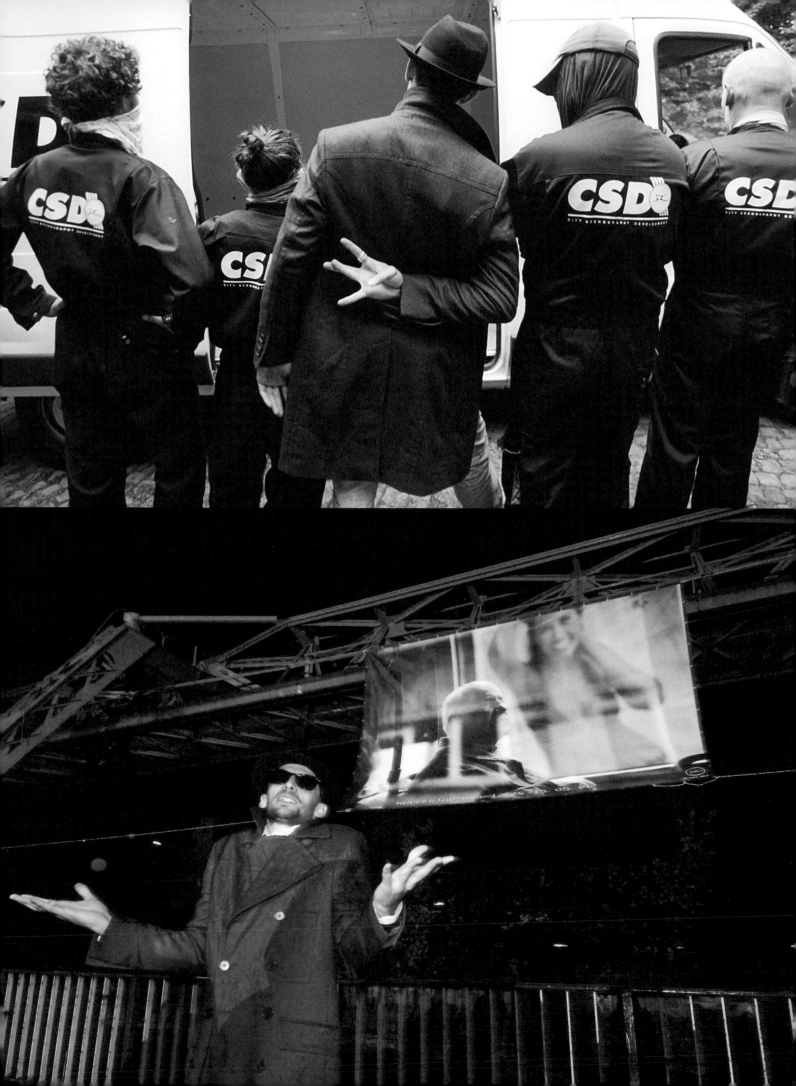

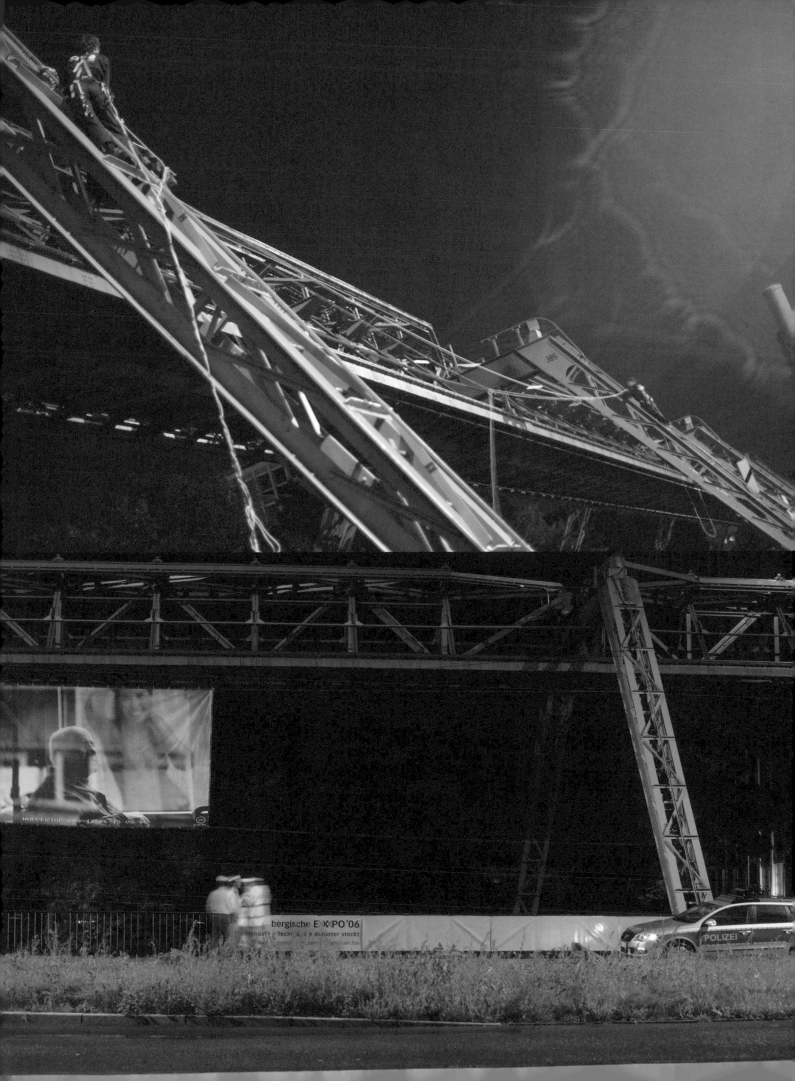

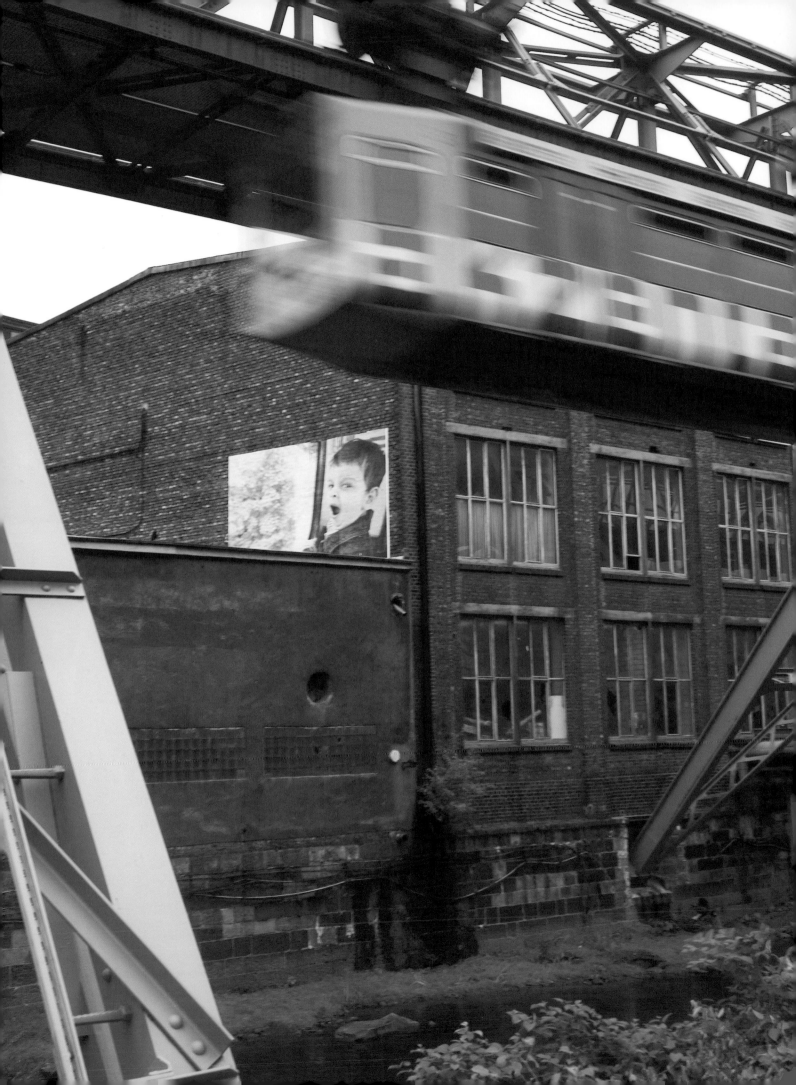

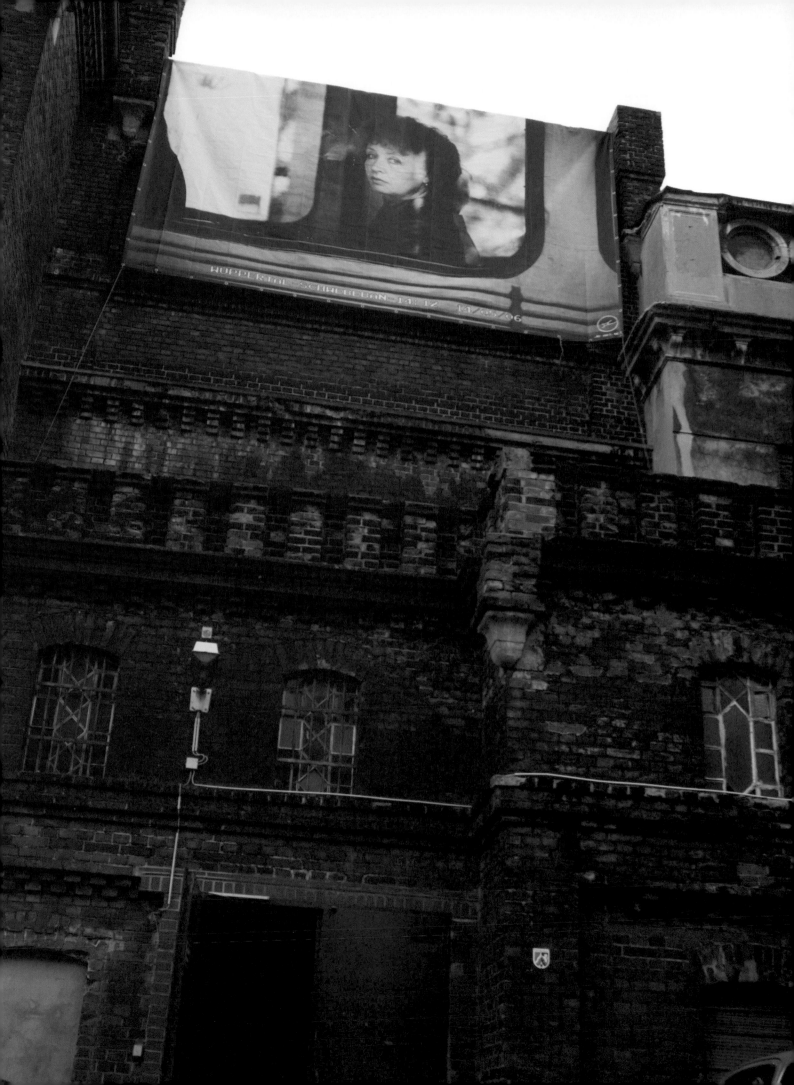

# IS WHITE A COLOUR? IS WHITE DIRTY?
## DR. INNOCENT

Dr. Innocent enjoyed an apprenticeship as a classic graffiti writer in 1990s East Berlin. Over the years he has experimented extensively with different techniques, materials and various media. In Wuppertal, he asked the question of whether white is dirty or clean.

## "WHITE SILENCE PERCEPTUAL PURITY LIBERATION"

Kalliopi Voikou

Don´t speak with a full mouth.
Don´t play with your food.
Finish your food.
Don´t bite your nails.
Clean your teeth.
Tidy your room.
Don´t pick your nose.
Wash your hands.
Stop fidgeting.
Sit straight.
Don´t touch this.
Don´t put it in your mouth.
First homework, then play.
Go to your room.
Go to bed.
Mind your step.
Hurry up.
Stay in line.
Ask first.
Don´t bother me now.
Always tell the truth.
Tell me who did it.
Don´t play with fire.
Be quiet and listen.
Speak up.
Don´t interrupt.
Don´t speak back to me.
Do as you are told.
Stop whining.
Say please and thank you.
No foul words.
Mind your manners.
Respect your elders.
Don´t talk to strangers.
Don´t wander off.
Be careful.

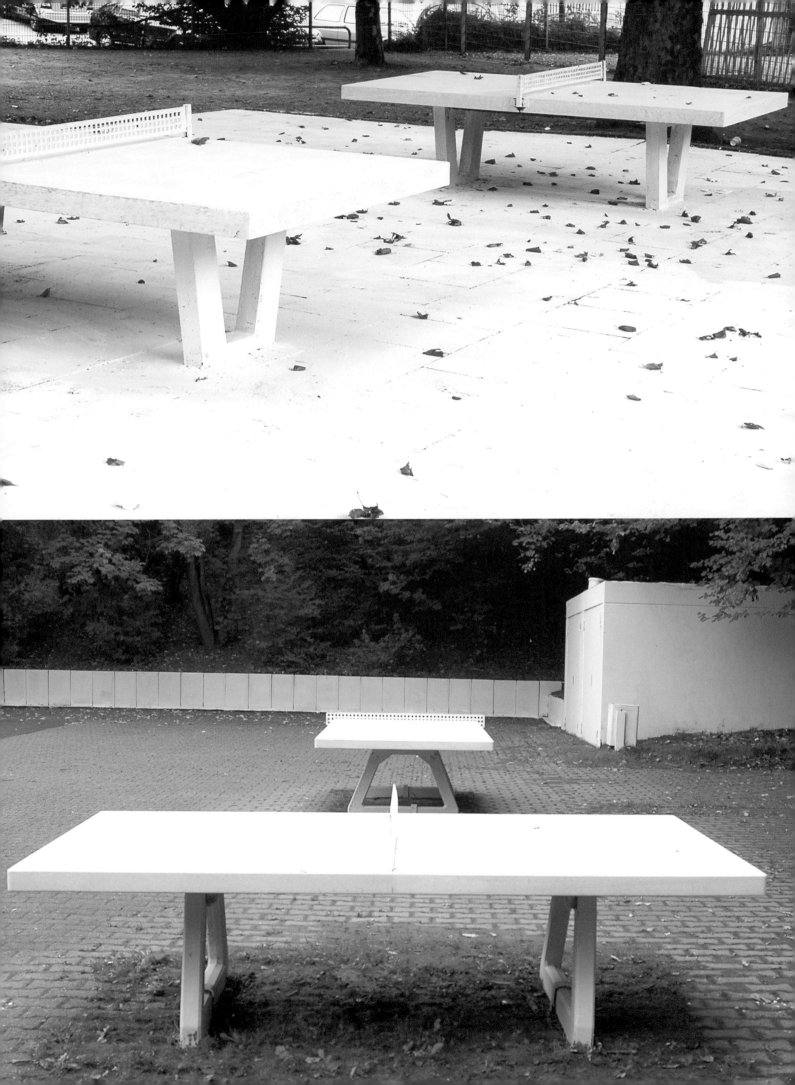

## "VOID FOCUS
## PLENUM PERCEPTION
## APOCALYPTIC ANTITHESIS"

Kalliopi Voikou

Don´t smoke.
Don´t drink and drive.
Just say no.
Use a rubber.
Shit happens.
Be fit.
You can´t continue like this.
Have fun.
Turn the music down.
Don´t be negative.
What will the people say?
Think of the future.
Don´t be late.
Be sensible and practical.
Be responsible.
Take it easy.
Think straight.
Be flexible.
Be the first.
Grab the chance.
You can be anything you want.
All doors are open.
Did you find a job?
Trust yourself.
Use your head.
You are too young.
You are old enough.
Stand on your own feet.
Follow your dream.
Be a doer not a dreamer.
Don´t be a loser.
Take care of yourself.
Don´t lose time.
Relax.
Grow up.
Be yourself.

## "ACTIVE SILENCE INTEGRATION REVERSAL"

Kalliopi Voikou

Do it.
First come first served.
Buy now, pay later.
The key to success.
Pay by card.
Without risk.
Full guarantee.
The taste of freedom.
Low budget.
Your world of entertainment.
Wellness and spa.
Stay young.
Explore your limits.
Happy hour.
Cholesterol free.
Online shopping.
Free call.
High quality low cost.
Your chance to win.
Live your dreams.
Tax free.
It´s a must.
Never stop.
100% natural.
Feel the difference.
Premium member.
You are the star.
Hot spot.
Easy money.
Sales opportunities.
Invest wisely in your future.
Insurance policy.
Prepaid benefits.
You make the difference.
The choice is yours.
Be connected.

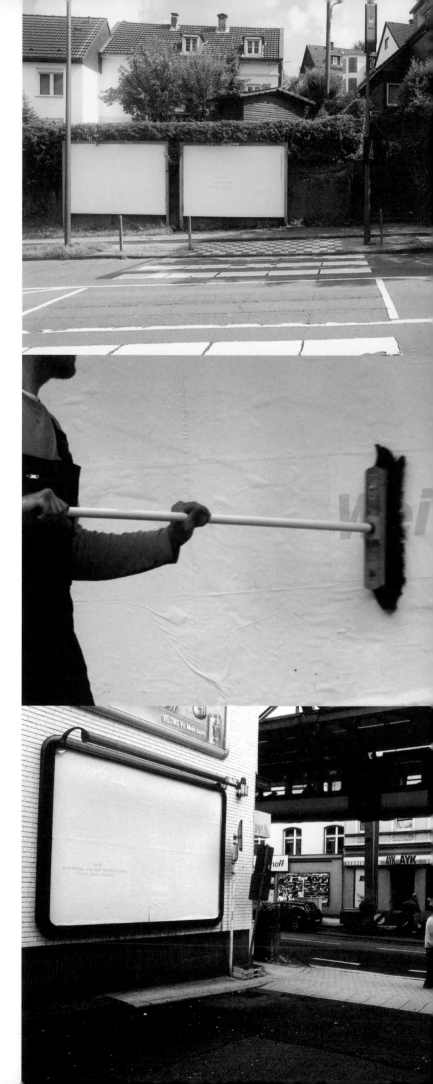

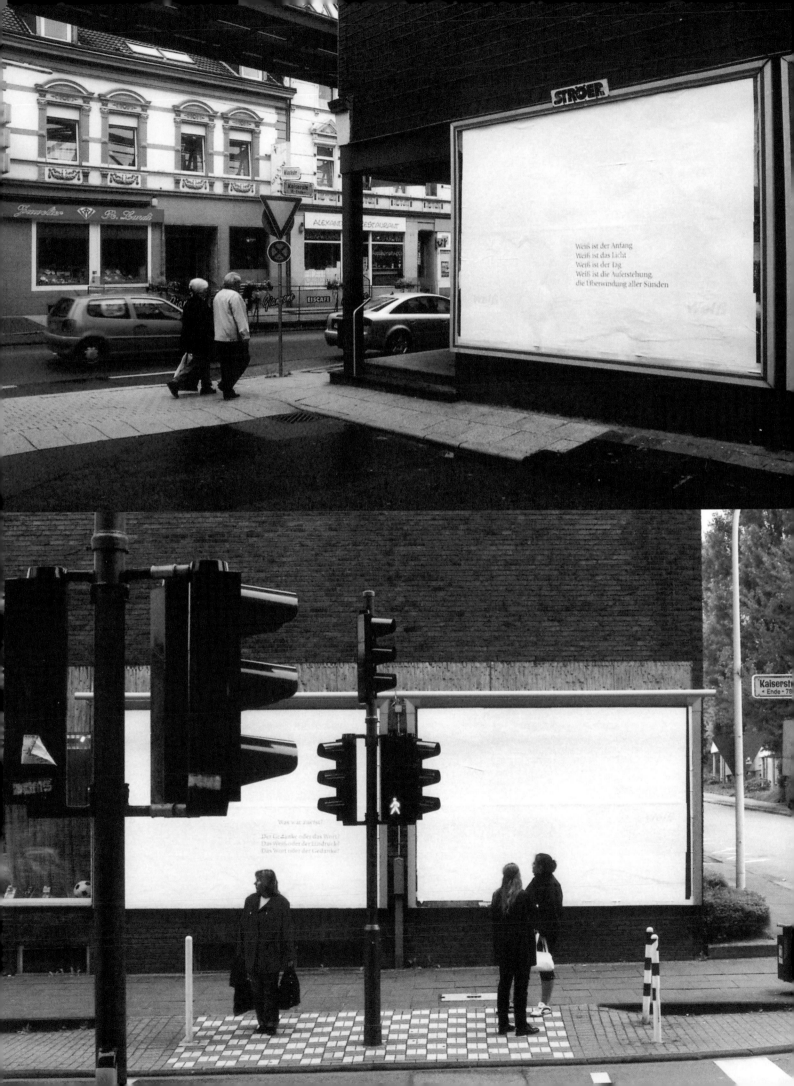

Weiß ist der Anfang
Weiß ist das Licht
Weiß ist der Tag
Weiß ist die Auferstehung,
die Überwindung aller Sünden

Was war zuerst?

Der Gedanke oder das Wort?
Das Weiß oder der Eindruck?
Das Wort oder der Gedanke?

## "WHITE AND SILENCE ANTIDOTE INTELLECTUAL SYNCHRONY"

Kalliopi Voikou

Take a seat.
So active for your age.
You are still young.
Give way to the young.
Enjoy the fruits of a lifetime.
Now you´ve got so much free time.
Does your insurance cover it?
A paradise for mature citizens.
We are always here for you.
We´ll come back again.
Now you are free to do whatever you want
Stay healthy at your old age.
Do you need any help?
Did you take your pills?
It´s good for your bones.
Mind your step.
When is your next check up?
You don´t look your age.
Look who´s here.
Do you remember me?
Can you hear me?
It´s no good for your health.
An apple a day keeps the doctor away.
The golden years.
The catheter is full.
Use a straw.
You are in such good condition.
You´ll live to be a hundred.
Second spring.
Can I help you across?
We still need you.
You can hold onto me.
Old age is no obstacle.
You can´t do this anymore.
It comes with old age.
Be positive.

# AKIM ONE MACHINE

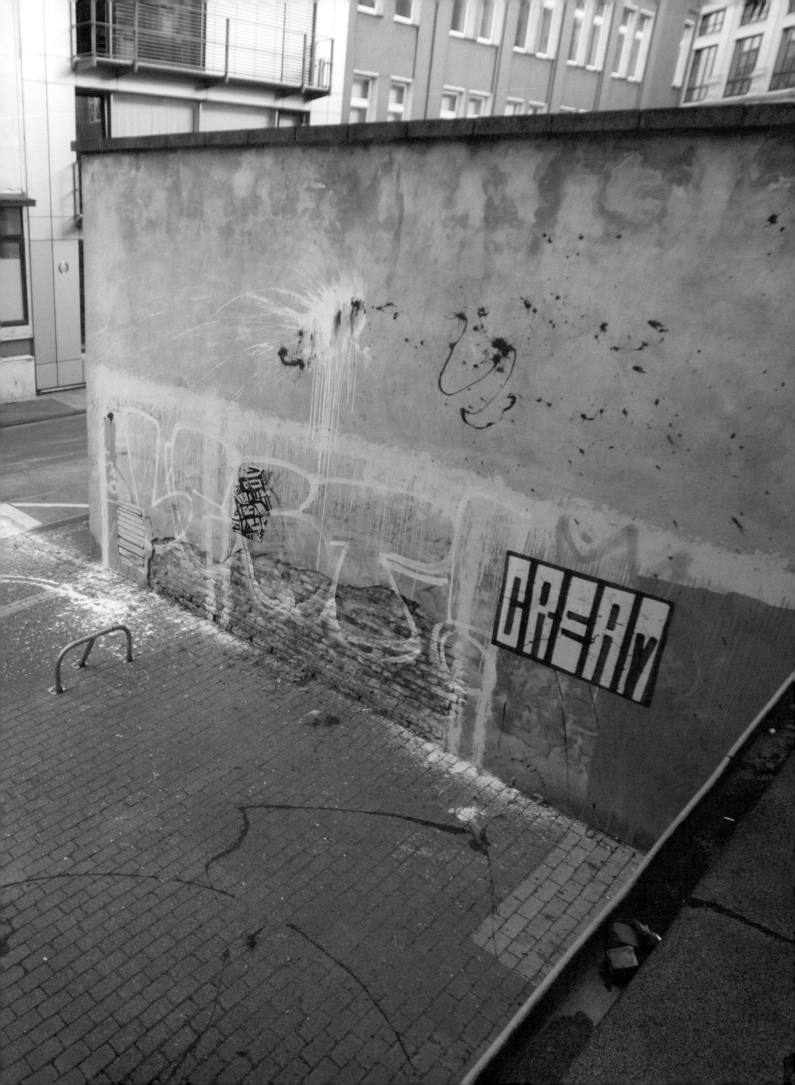

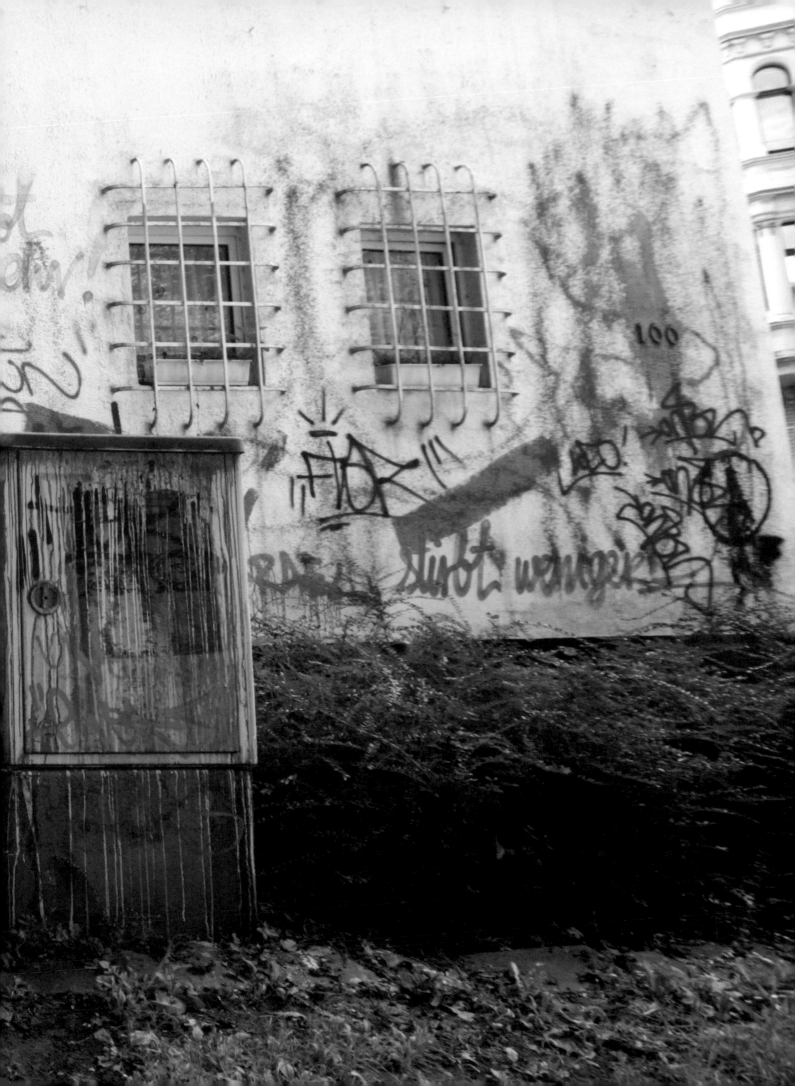

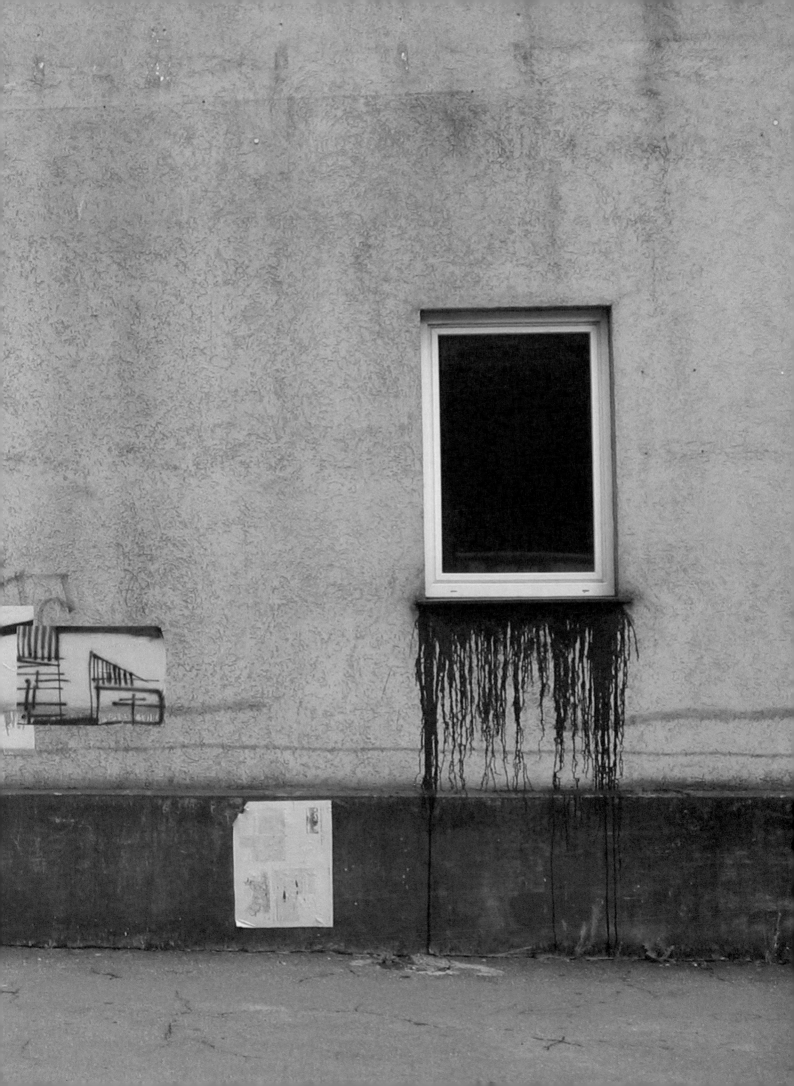

# FREE PRESS
## BLU

The artist Blu from Bologna is known for his very large, often surreal and aggressive, but always strong pictures in the public space. His very playful and comic-style pieces often carry an ethnic, political or moral statement, yet without being patronizing. Apart from his works in the public space, he frequently draws graphics and uses the pictures in animation films. In Wuppertal, his central theme was the daily "information overkill" in the public space. He worked with so-called "free" magazines which are forced on us at every street corner. They hardly ever have any interesting or relevant content, but are instead completely packed with adverts. For the project, Blu produced and distributed 6,000 of these "free" magazines himself. Blu chose this format and published his pictures anonymously and without any commentary, explanation or further information. At the same time he worked his art on various walls in the city, thereby creating a reference to the drawings and his extensive pieces in the public space.

*What was the idea behind your project?*

6,000 books of drawings placed everywhere around central streets, train stations, bus stops, traffic lights and any other place where people usually walk. A gift for all the people going to work or school the next day. It was a kind of "street art take-away" exhibition; if you like the piece, you can take it home. The magazines were completely anonymous and I think most of the people will never know that I did it.

*How did you develop your project?*

I printed the books in my city and brought everything to Wuppertal in a van. That night about 6 of us (until three of us were caught by the police) walked around with orange trolleys full of magazines and boxes. We started distributing the boxes by tying them onto poles and traffic lights using plastic belts, but then it began to rain so we decided to put all the magazines in the Schwebebahn stations and bus stops on the main roads. That night

every bench was full of magazines and the next day many people were walking around with a magazine in their hands.

*Why did you decide to be part of the project?*

First I was attracted by the possibility of doing something more than the common wall painting (which I did anyway), using a budget I don't have myself. Also, the other artists involved in the project were a big attraction for me. Some of them are really good friends and I'm always pleased to work with them. It was also an opportunity to meet the other artists who I hadn't known personally before.

*What was special about the project?*

The thing that was most special was the get-together and exchange I had with the other artists. It was a precious and rare opportunity to meet all those people who are such great artists and individuals. Everyone came from a different part of the world and each had their own experiences and a

desire to know more about the others. This contact is the thing that will really last longer than the work we did, longer than the project itself. We also had many long and interesting talks about what we were doing there, the way we were working with the support of this company, and our personal relationship with the project. We were searching for the perfect compromise - which is impossible in the end.

*What do you think of Wuppertal as a location for this kind of exhibition?*

It's a really nice city, full of nice inspiring architecture: the Schwebebahn train line, lots of empty factories, old bunkers from the Second World War, and the abandoned rail track with its tunnels and bridges.

*Do you think the frame of OUTSIDES can be a role model for further projects?*

The concept behind OUTSIDES was not first invented with this project. A similar project had been done in 2005 in Berlin (without any sponsors), and that's where the idea came from. OUTSIDES had already taken the project in Berlin as a model, which was a development based on the idea of going out and painting together. The special thing about OUTSIDES was the involvement of a company which gave the money and technical support needed to realize the project in a bigger way, with the clear intent of appearing in the media, especially within the graffiti and street art community.

*www.blublu.org*

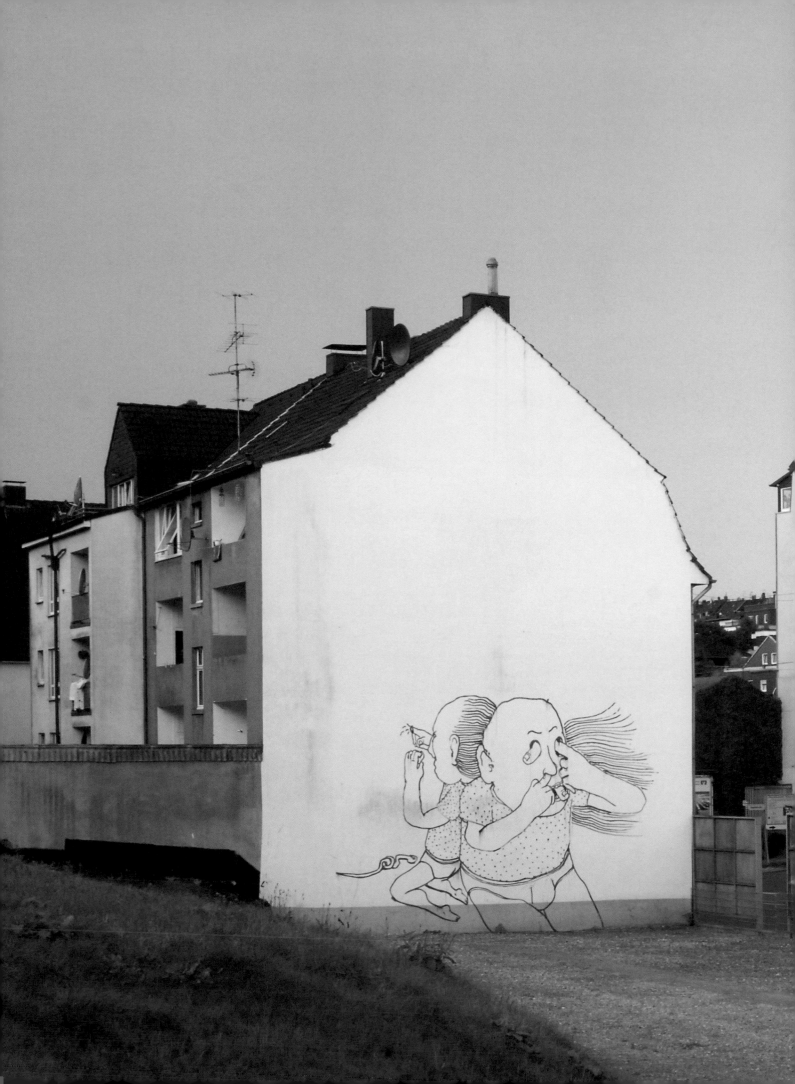

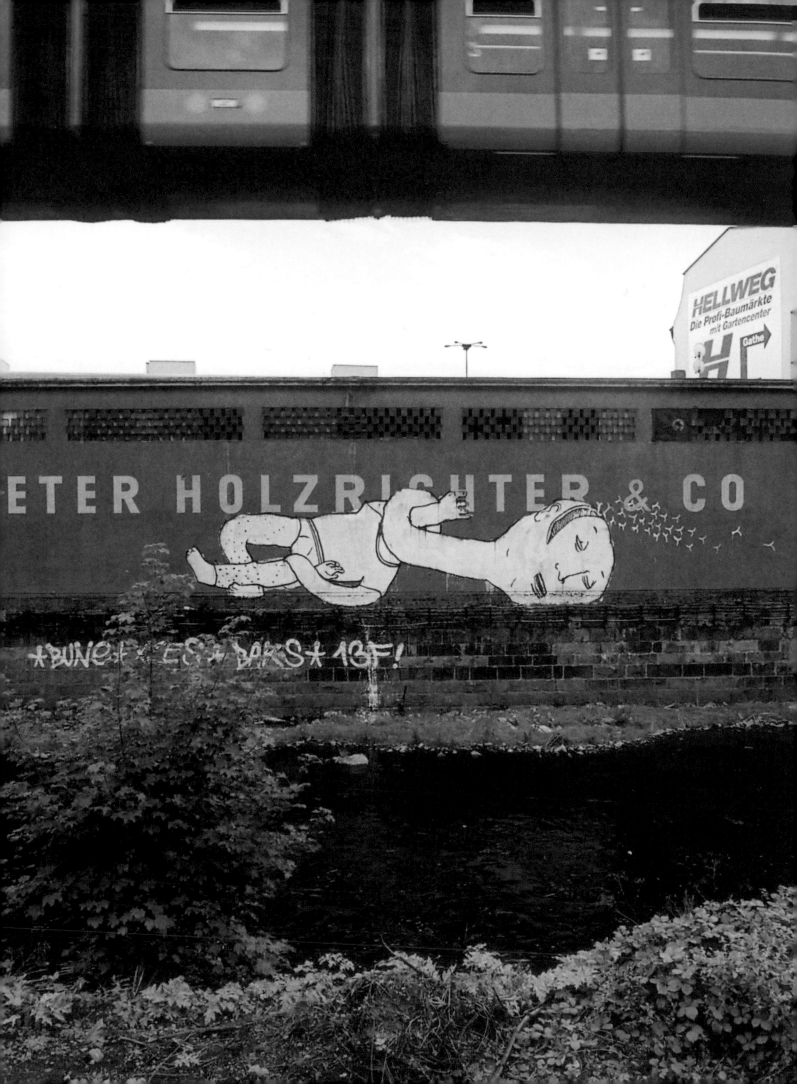

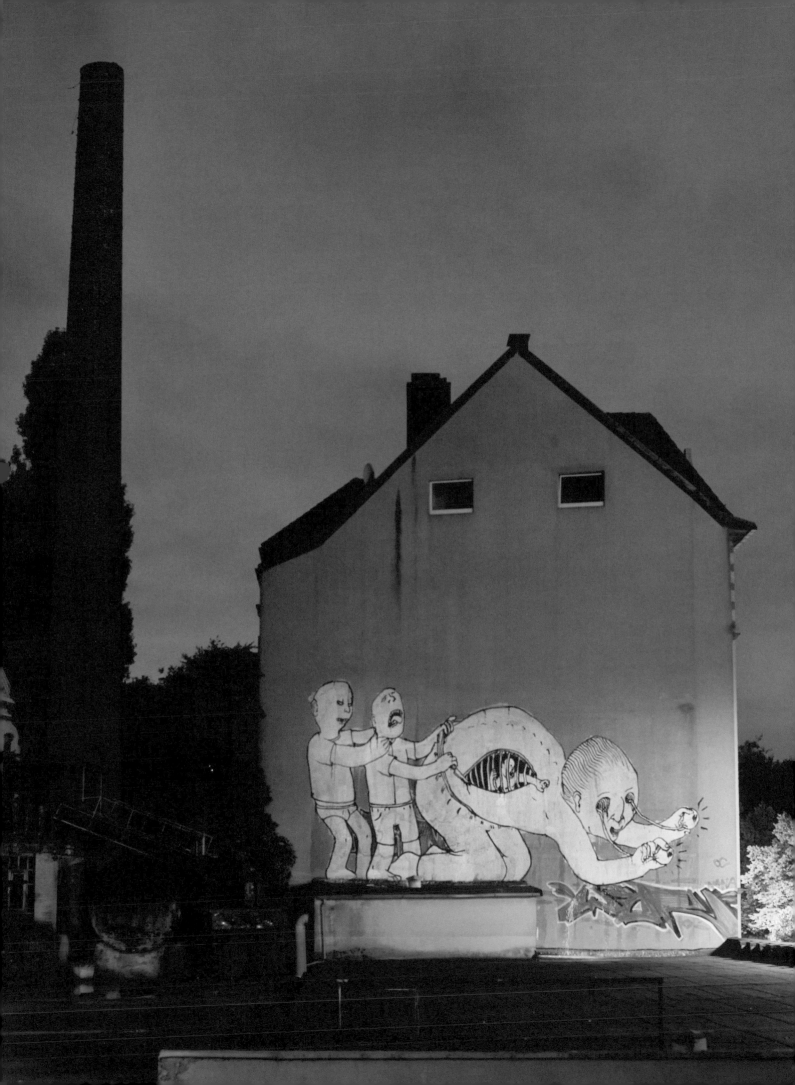

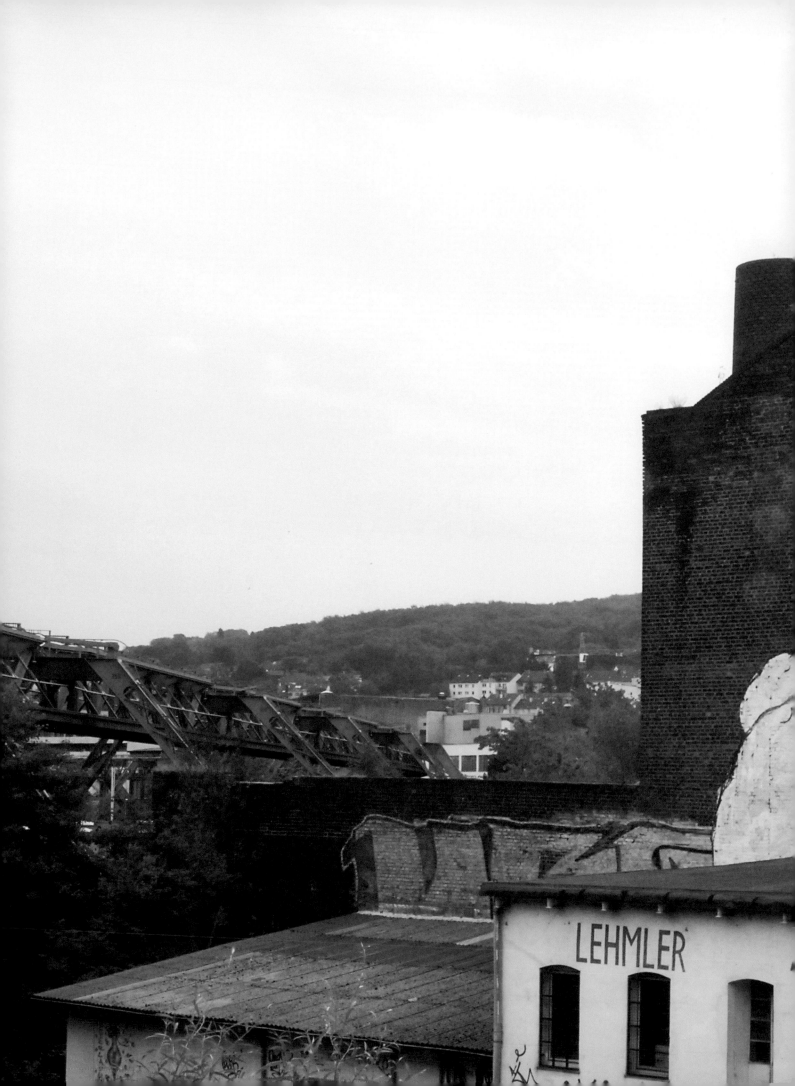

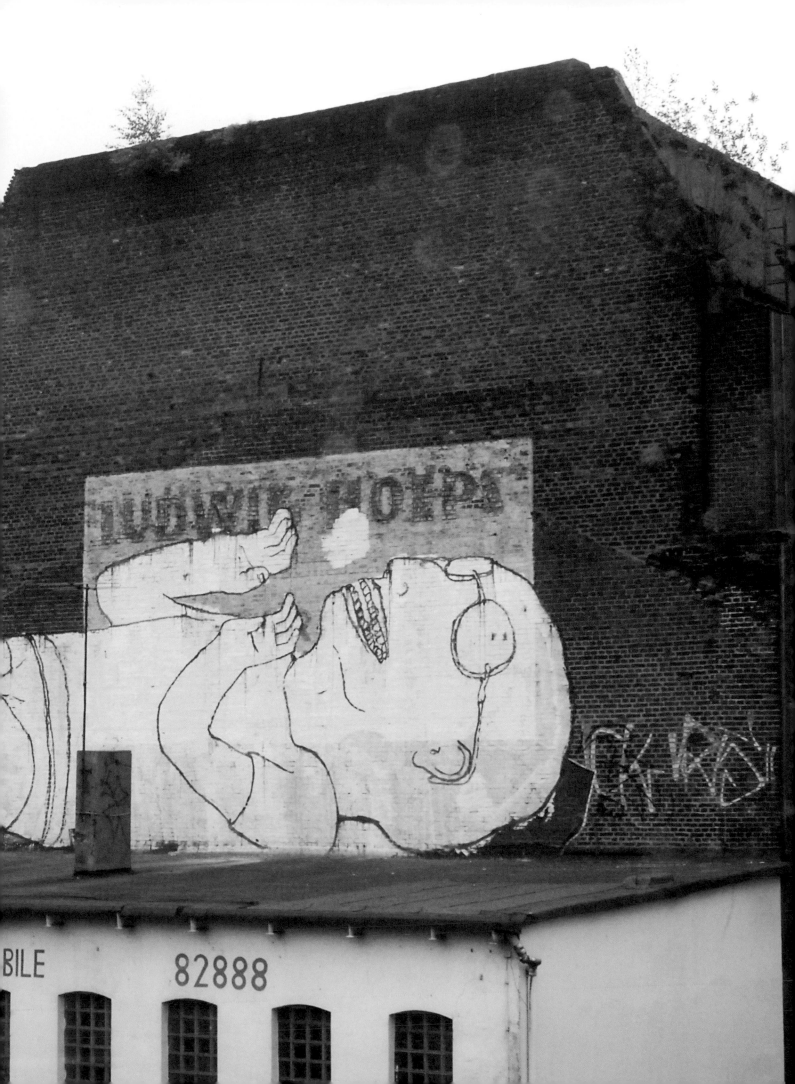

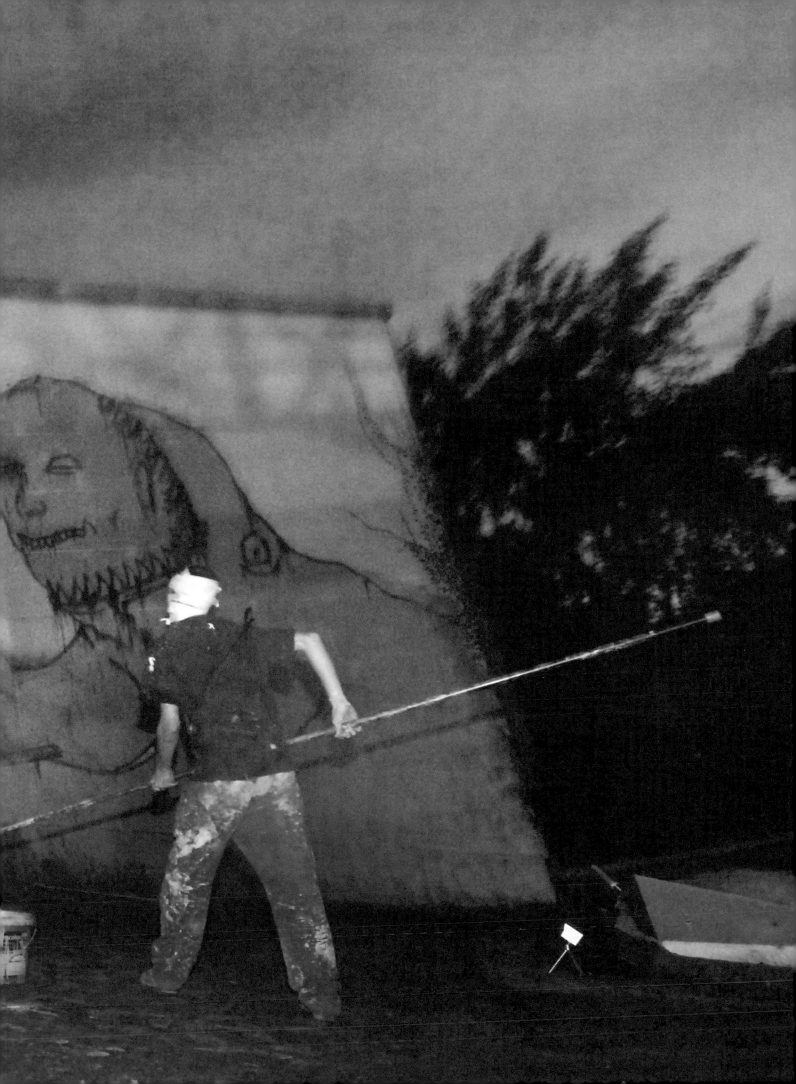

# OUTPUTS
## BROM

Brom has been working as a graffiti artist since the mid-90s. His participation in many projects at home and abroad has led Brom to investigate closely the effect of art in the public space. In Wuppertal, he consciously decided to present his work indoors, on canvas, at a location rented especially for this occasion, in order to question the whole framework of the project.

Can graffiti survive the transition from open street to art gallery? Is mere knowledge of the origins of the work sufficient for it to be seen as graffiti? What is graffiti anyway – a style, a method, an action? I found myself wondering this, in relation to the OUTSIDES project in Wuppertal in 2006, and an answer still eludes me. The fundamental idea behind graffiti and so-called "street art" today is that it is based on the artist taking their own initiative independently and unofficially to form the public space around them. This idea usually strives to be visible, to be noticed – to be in the public eye. The point is to present and express yourself in a place of your own choice. This principle of public display is very similar to that of advertising. However, graffiti takes the idea behind commercial advertising to the absurd – in graffiti it is the image of self which is being advertised. A piece of graffiti promotes itself and a fictitious character which the creator has invented. There is no tangible product involved. Or is there?

Brom promotes Brom, but can you buy Brom?

This was the central issue around which I built my project.

What makes OUTSIDES unique in comparison to other graffiti & "street art" projects is that it is a collaboration.

A well-known company provided funds for the project – in fact, the company was the initiator.

The conditions for the project between artist and business were discussed at length and a consensus was reached.

The artists were granted a substantial degree of freedom in their work, in the initial phase, and the company remained in the background – an arrangement which was in the interests of all involved. However, as soon as graffiti loses its autonomy, its self serving nature, it loses itself. The connection to a large company renders the ultimately free work of art, the mere vehicle for a product. In other words, a sponsored art project promotes, with the image of the art, the sponsor; and that is no secret.

So how is it possible to deal with this reality responsibly and to be fair to all involved? The question is, "What can I give, and what can't I?" At this point, content and form are separated from one another. The project, the occupation of public places, is surely at the heart of graffiti. The designs which are created are simply traces of the act itself. These traces in this case are existential – they are the very manifestation of their creator's aims. That said when these traces are divorced from their relevant location, they lose part of their expression.

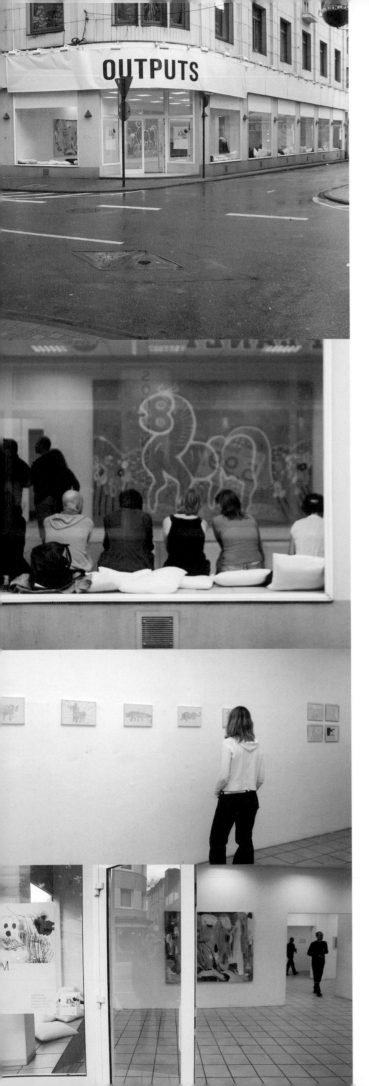

Still, the design of the graffiti seems to transmit a strong image. The design and the act are often seen as the same thing. Personally, I do not see the work on display as graffiti. Rather it seems to be a way of dealing with the motifs contained within the graffiti – the words, the synonyms. A play on a word, transforming it artistically, is the formulaic approach. The result can be graffiti in the right place; here it fulfils a different purpose. The examination of the "word as object" serves as an examination of painted art itself. It is then up to each of us to decide whether or not these works transmit the idea of "street art".

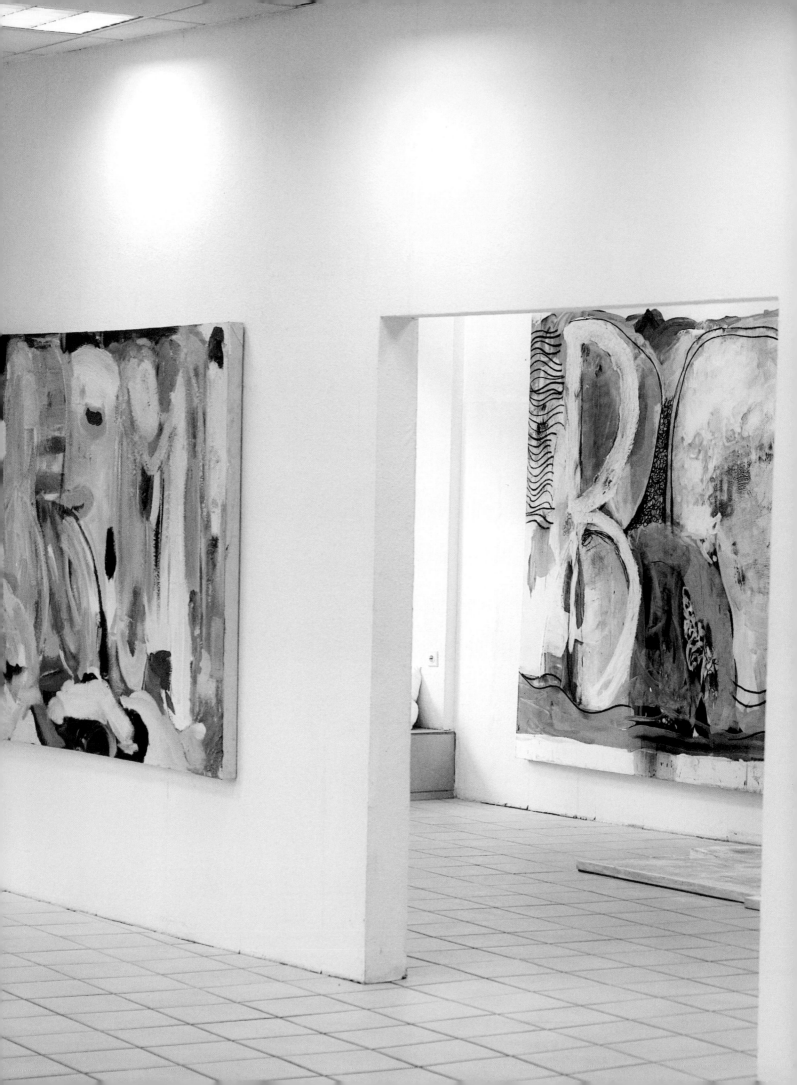

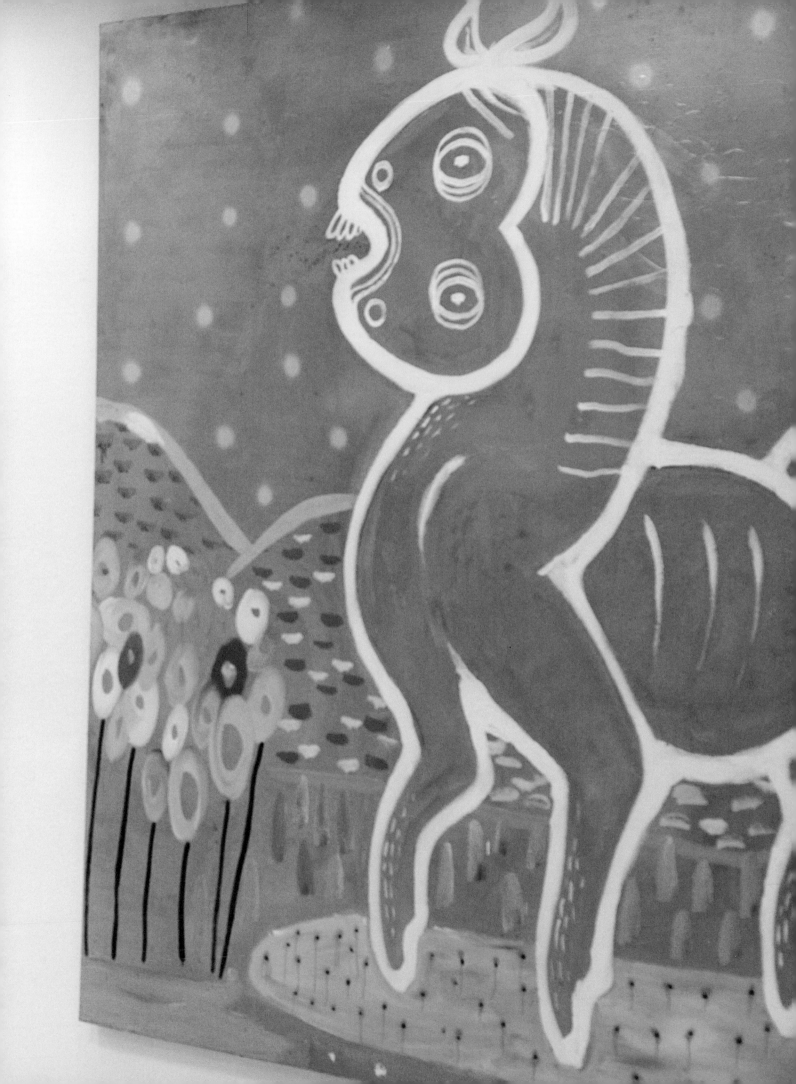

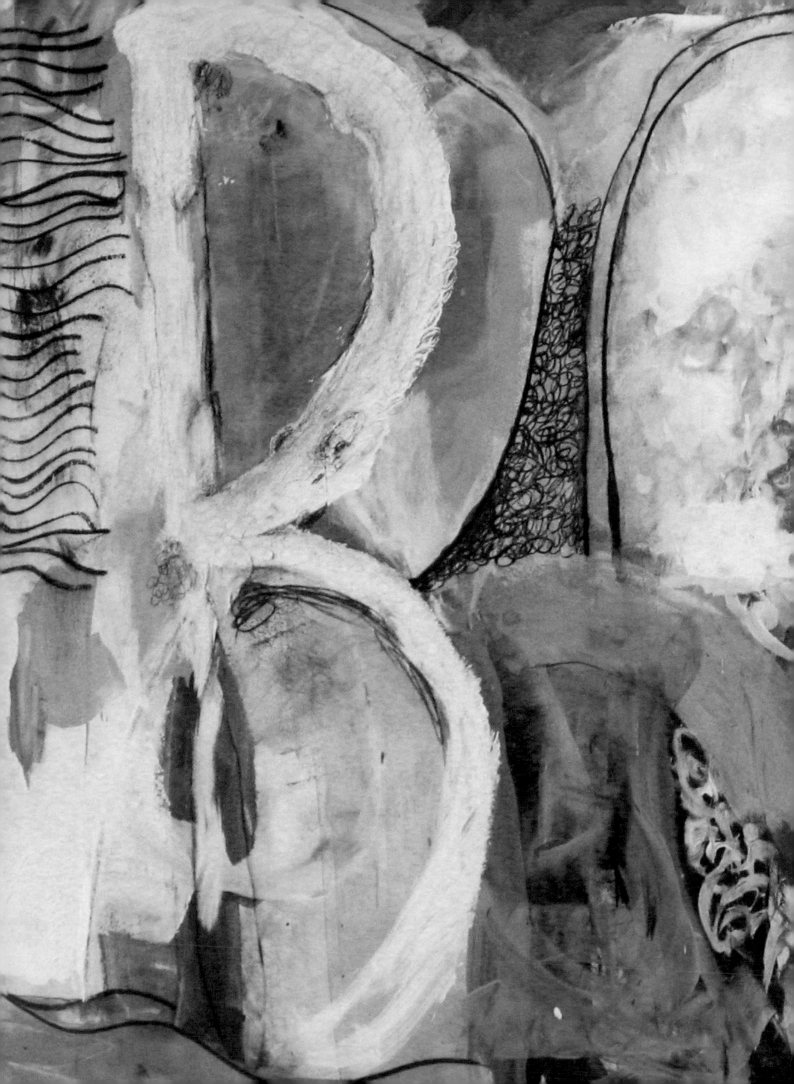

# MOMENTS OF SUSPICION
## REVIEW BY WOLFGANG ULLRICH

On the morning of August 18, the inhabitants of Wuppertal awoke to art installations, billboards and wall paintings, which seemed to have appeared overnight. Many also found a flyer entitled "OUT-SIDES", which appeared to be a note claiming responsibility. The flyer, which did not reveal the identity of its author but was signed anonymously "xxx", informed them that a group of artists had distributed a total of 22 art works all over the city. Soon curious people were walking up and down the streets, guided by the vague information given on the flyer as to the whereabouts of these art works. While doing so they could never be sure beyond a doubt whether a piece of graffiti, a painted lamp-post or an object resembling a horse belonged to the OUTSIDES project or not. Thus, searching for and sensitized to art, they couldn't help simply suspecting everything they saw to be part of this larger project. They saw things and details which had never caught their eye before, and the streets and squares they had walked on so many times in the past suddenly appeared in a new light.

However, some things could be easily recognized as part of the project, as was the case with a couple of large photographs which had been hung on the front of buildings facing the elevated railway line. The photographs, which showed people travel-ing on the elevated railway, drew considerable controversy as some of the people shown in them recognized themselves (and would rather not have in some cases). Other works gave the impression of being a gag: a metal sculpture had been placed on a plinth, which had otherwise stood empty in the square for decades. The sculpture was clearly conceived as a parody of modern art and its aloof abstractions (and it disappeared after a couple of days as unexpectedly as it had appeared).

Yet it wasn't the provocations and punch-lines - which can also be found in many other official art exhibitions held in public spaces - but the project's secretive nature that drew people's attention and aroused discussion, as well as intrigue. Not even the city's administrators had been informed, and the OUTSIDES project seemed to have nothing to do with the Regionale exhibition, which was being held in the region at the same time. Rumors began to circulate but none of them seemed substantiat-ed. What would the Bonn Guggenheim exhibition have to do with street art in Wuppertal? And why should a private art collector be interested in hav-ing a whole city fitted out with 'his' artists' works without permission. If it came out he might have to face a costly claim for damages, if it didn't there wouldn't be any positive image effect for him.

Those who set out to investigate a little more, however, were soon to realize that it wasn't only local artists who had been involved with this project in Wuppertal. Internet searches for the names mentioned on the flyer would end up on the websites of the international street art and sprayer community. Most of the artists who gave guest performances in Wuppertal - such as JR, Zevs, Os Gemeos or Blu - range among the most famous, world-wide figures who operate in this alternative "cultural sector" - which exists alongside the official cultural sector.

Working illegally and holding events without permission is an essential trait of the sprayers' and street artists' style. However, the scale and variety, as witnessed in Wuppertal, had seldom been seen before from this scene. Those who knew the scene had to arrive at the conclusion that this was a curated and well-prepared project. But this would mean that the underground scene had adopted

methods which have been common practice in other fields of art for many years. In fact, curators have become the protagonists of many exhibitions and events. It is they who receive all the attention, not the artists involved. In Wuppertal, however, they remained anonymous, a part of the mysterious plot.

This way curiosity was spiced up further still. Not only was the intrigued public left in the dark as to what was part of the project and what the reason behind the whole thing was, but also as to who had initiated it conceptually (and also financially). Those Wuppertal citizens who observed the events from a somewhat more critical point of view, however, might have wondered why the OUTSIDES group considered it so important to operate illegally. After all, it is most likely that permission would have been granted for almost all their art works had they asked for it; they were not so dangerous or off-limits as to make it necessary to evade administrative approval. Quite the contrary is the case - administration officials have now committed themselves to preserving some of the pieces of graffiti. Hence, the strategy of creating intrigue by operating anonymously, ultimately ended up calling the project itself into question. Weren't the initiators interested in arousing speculation? They surely wanted people to discuss and dispute the sense (or senselessness) of such a project. And didn't they want to ensure that "OUTSIDES – A Red Bull Street Art Project" would become an even greater sensation than it was?

## WOLFGANG ULLRICH (*1967)

studied philosophy and art history in Munich. Since his doctorate in 1994 he has worked as a freelancer. He is the author of several books on the history of concepts of art, on (post) modern visual phenomena, and on consumer culture. In 2006, Karlsruhe University of Arts and Design offered him the Chair of Aesthetics and Media Theory.

# "A CAN IS A CAN IS A CAN ..."
## REVIEW BY FRANZ LIEBL

## STREET ART AND THE GREY-ZONE MARKETING OF RED BULL

### BELOW THE (WAIST)LINE

"Classic is dead! Classic is dead!" This is not the battle cry of heavy metal fans or techno kids, but has been, for more than 10 years, an endlessly repeated diagnosis among advertising professionals. The term "classic" basically refers to all conventional advertising channels, i.e. mass media, such as television, radio and print formats. As everybody knows, these channels have lost much of their power: special interests of target groups are becoming increasingly fragmented and, therefore, media segments are becoming smaller; the number of niche-blogs is exploding, and TV spectators are forced, by a multitude of boring programs, to zap continuously. That's why a number of alternative advertising techniques have steadily gained ground over the past ten years. They are termed "below the line", and those who can't help but think of "below the waistline" when hearing it are not all wrong. What is showcased as the spearhead of innovation in the marketing communication sector, on closer inspection, turns out to be a cabinet of horrors.

While product placement – commonly known as "surreptitious advertising" – in TV and cinema might be justifiable as a means of making movies and TV series more realistic, many public and customer-related events have never gotten beyond bouncy castle level. However, the least imaginative form is cultural sponsoring, the prime discipline of "me-too" marketers. In general, it follows the wash-my-neck-but-don't-get-me-wet principle, accompanied, in some cases, by the sponsor's exaggerated claim for control or, in others, by his complete lack of interest. In short, sponsoring companies either want to have it all their way or they let you know in a more or less subtle way: "Take the money and do with it as you wish, as long as our company logo appears on TV." In the high culture sector a third variant seems to become more and more popular: giving awards to artists in order to benefit from image transfers or to feign expertise (Liebs 2006).

The only advertising discipline which has had its sparks of ingenuity now and then is guerrilla marketing. But as guerrilla activities today belong even to the standard repertoire of marketing freshmen, the concept, which benefits from being a rarely used and exceptional strategy, is prone to decline. When subversion becomes ubiquitous, the general audience will not only see through its mechanics but also raise their expectations: "Well then, go ahead, show me some nice subversions and surprise me…". When the "détournement screw has been turned once too often" (Edlinger 2006; see also Düllo/Liebl 2005; Class 2006), this is a challenge which can hardly be met.

If everyone does the same, then there will be no competitive advantage in the market. But who has got the courage to do things differently – or will even do different things? No matter where you look, currently there is not much to see. Even the latest marketing trends will hardly pass the sustainability test: Avatar-based Marketing, Eggvertising, Breker-style Advertising – the half-life period of nice but irrelevant ideas is constantly diminishing. What we are waiting for are genuine transgressions.

## THE COURAGE OF MANIACS

Throughout the history of advertising some companies have successfully made such transgressions. In Austria for example. In the 1970s, Humanic, a Graz-based shoe retailer, launched advertising campaigns that became milestones in the history of marketing: thirty-second TV commercials created and produced by artists like H.C. Artmann, Gerhard Rühm, Axel Corti or Richard Kriesche. Radical avant-garde and conceptual art for the Austrians, supported by the pretentious claim: "Humanic paßt immer" (i.e. Humanic always fits). Art sponsoring in TV commercials – and that's what it basically is – would be unthinkable in present times, although allegedly anything goes today. It's because this grey area – i.e. the Bermuda triangle of advertising, art and sponsoring – wouldn't survive the pre-tests made by desperate researchers and required by marketing controllers. Well, back then this courageous communication strategy of the self-proclaimed "Shoemanics" – and courageous it was because it seemed both absurd and transgressive – turned out to be a comprehensive success. This positive result was thanks to the mobilizing campaign which split the nation into two factions. The general awareness of the brand among Austrian consumers even surpassed Coca-Cola's for a while.

Tu, felix Austria, seem to have more of these maniacs. In the tradition of the Humanic campaign, a contemporary follow-up project called "OUTSIDES – A Red Bull Street Art Project" has been set in motion. Again, its initiator regards the mobilization and polarization of the campaign as maybe having an expected side-effect – admittedly not on a whole nation but, at least, on a metropolitan area. However, at second glance, "OUTSIDES – A Red Bull Street Art Project" reveals an even bolder conceptual idea than the Humanic campaign. It is, in various respects, a radicalization of the development and handling of grey zones.

## THE GREY ZONES OF OUTSIDES

It is not unusual for consumer goods manufacturers to hire street artists for "guerrilla advertising" in order to promote the company logo and increase the street credibility of the brand. These projects have recently been well documented (Lucas/Dorrian 2006). Also, it is a fact that many exhibitions which feature works of street artists get support from commercial entities, e.g. the billboard project, "La rue aux artistes", was sponsored by the media company Viacom (Garouste 2004). However, as far as I know, there is no precedent for a company paying a large number of street artists to cover a whole city with their art overnight and without prior notice. Whilst doing this, they operated in grey zones and ambivalent areas, hence, a differentiated analysis is called for. In my opinion the following three considerations seem to be the most important ones:

– There is no doubt in that we are dealing with a legal grey zone here. The mere fact that some people consider street art to be nothing but worthless smearings on the wall and willful damage to property, while others call it a legitimate form of "Avant-garde 2006/2007" (Düllo 2006), sustains this position. Apart from this, a number of innovative artists, such as Zevs, use concepts like "Inverse Graffiti" or "Proper Graffiti" that cleverly test the boundaries of legality. They create artworks which result from selectively removing dirt from the wall with cleaning devices, instead of applying paint to it. The ambivalent nature of the topic became most apparent in the statement of the newly designated head of the Wuppertal department of culture. She used metaphors which relate to the infamous cargo cult – in which the line between blessings and curses was also very thin.

– Yet the artists have also ventured into an aesthetic grey zone of their genre, which has given rise to much controversy. Never has street art been closer to "conventional art" than in "OUTSIDES – A Red Bull Street Art Project". While former street art exhibitions presented little more than a "Street Art Style" within domesticated art spaces, such as Billboards or White Cubes, some artists suddenly sensed the opportunity for more ambitious projects when confronted with the budgets offered. Thus, the boundaries of street art were stretched to an extent that made it hardly recognizable as street art anymore. "Art in the wilds" would probably be a more appropriate term for what is reffered to as street art here.

– And last but not least, we are dealing with a conceptual grey zone with respect to marketing as such and the instruments applied.

"OUTSIDES – A Red Bull Street Art Project" turns out to be a category killer because it cannot be properly framed by using conventional marketing categories. It represents neither genuine sponsoring nor a guerrilla advertising campaign nor a typical event. It is also, by no means, a tribal marketing campaign – a couple of additional (Red Bull) cans sold to the sprayer community and its sympathizers wouldn't have much of an impact on the company's sales.

## ORGANIZATIONAL DEVELOPMENT AS A NON-CONFORMIST MARKETING STRATEGY

But what is it all about then? Maybe the key to this question is that "OUTSIDES – A Red Bull Street Art Project" is not at all about marketing but, rather fundamentally, about organizational development. In a time when graffiti (along with street art) is well on its way to being recoded from an "aesthetics of resistance" into simple "street art style", a sponsor wouldn't gain much authenticity by just superficially referring to such styles, for that's something even Deutsche Bank has come to do. Therefore, in order to stand out from everybody else, one has to do something the others wouldn't risk doing. In his book, *Brand Hijack: Marketing Without Marketing,* which discusses advanced forms of brand management, Alex Wipperfürth (2005, pp. 57 f.) writes about Red Bull, "But unless you have dedicated buy-in from your employees …, the vibe will never cross over to your consumers. Employees serve as credible role models, aligning the internal values of the company with the external values and principles of the brand. You need to move your own people before you can touch a removed audience. …Red Bull employs a fully committed team hired primarily for its passion about the product and non-conformism." When a company conjures up the nerve to do such a thing and admit responsibility for it, the effect will be an increased sense of corporate identity within the organization and an increased level of identification with the brand among consumers. This is because consumers will perceive a credible concordance between the brand's claimed values and the brand's and company's image. In this case, according to Wipperfürth, "non-conformism" is meant to be the company's central value. Initiating, implementing and admitting the responsibility for "OUTSIDES – A Red Bull Street Art Project" very much corresponds to such a motive. Street style as such would, however, be perceived as an opportunistic and outdated move and therefore fail to produce credibility.

All things considered, we are – and again the title of Alex Wipperfürth's book succinctly makes the point – confronted with an example of Marketing Without Marketing. Admittedly, marketing and communication professionals who are shaped by the classic marketing school might consider this a grey zone and hard to swallow, but luckily enough we know better, "Classic is dead!".

# REFERENCES

**Class, J.-S.:**
Von der Subkultur zur Kulturindustrie: Aneignungsstrategien der Postmoderne; Stuttgart 2006

**Düllo, T.:**
What's up, Avant-Garde? in: Hek Mag, #3, Herbst/Winter 2006/07, pp. 86–89

**Düllo, T.:**
Liebl, F. (eds.): Cultural Hacking: Kunst des Strategischen Handelns; Wien 2005

**Edlinger, T.:**
Alphabet des Abfalls: C – wie Comme des Garçons"; in: The Gap, Nr. 072, Dezember 2006/Jänner 2007; p. 024

**Garouste, G. (eds.):**
La rue aux artistes; Paris 2004

**Liebs, H.:**
Mein Bild, mein Maler, mein Geld: Immer mehr Unternehmen vergeben Preise und fördern Kunst – nicht nur für die Kantine, sondern gleich für ganze Museen; in: Süddeutsche Zeitung, No. 281, December 6, 2006; p. 2

**Lucas, G.:**
Dorrian, M.: Guerrilla Advertising: Unconventional Brand Communication; London 2006

**Wipperfürth, A.:**
Brand Hijack: Marketing Without Marketing; New York 2005

## FRANZ LIEBL (*1960)

Dr. oec. publ., Dr. rer. pol. habil., is professor of Strategic Marketing at the University of the Arts, Berlin. He received his diploma and doctoral degrees in Business Administration from the University of Munich. From 1986 to 1994 he worked with the Institute for Systems Research (University of Munich) and was its vice-director from 1990 to 1994. In 1994 he became professor of Business Administration at Witten/Herdecke University where he held the Chair for General and Quantitative Management until 1998, followed by the Aral Chair for Strategic Marketing from 1998 until August 2005. Since 2005 he has also been involved with the MBA program at the Zollverein School of Management and Design, Essen.

His research and consulting projects include strategy development, strategic issue management, business design and marketing in the context of individualized societies. Since 1983 he has published numerous articles on youth culture, subculture and experimental music. Since 1982 he has participated in many mail-art and mail-music projects. In 1995 he introduced his concept of theory performance under the title "Unidentified Theory Objects of Trend Research"which, since then, has been a feature of numerous cultural, scientific and business events.

He is editor of two series of books – *Cognitive Strategy Concepts* and *Experience-based Lifeworlds* – and is a regular contributor to leading German business magazines. His latest books include *Der Schock des Neuen: Entstehung und Management von Issues und Trends* (Gerling Academy Press, Munich) and *Cultural Hacking: Kunst des Strategischen Handelns* (Springer, Vienna/NewYork).

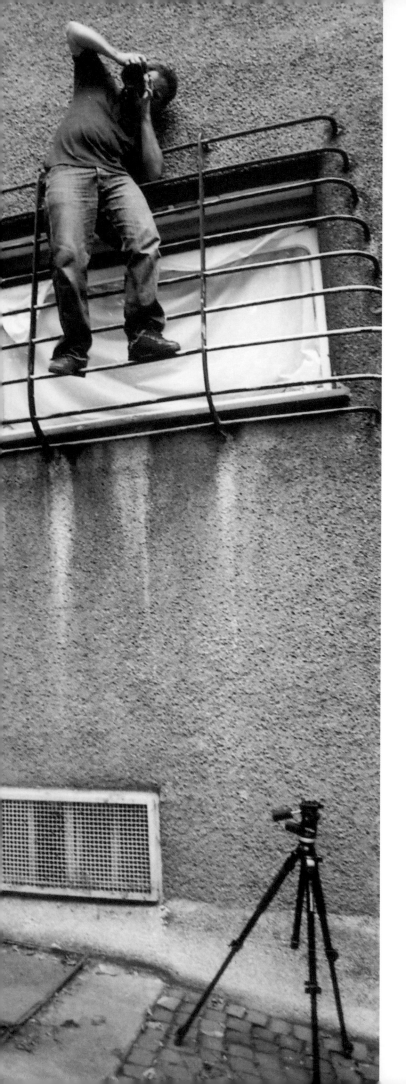

# PHOTOGRAPHERS

## MARTHA COOPER

Martha Cooper is a documentary photographer who has specialized in urban vernacular art and architecture for thirty years. In 1977, Martha moved to New York City and worked as a staff photographer at the NY Post for three years. During that time she began to shoot graffiti and break dancing, subjects which led to her extensive coverage of early Hip Hop as it emerged from the Bronx.

Martha's first book, *Subway Art*, a collaboration with Henry Chalfant, has been in print over 20 years and is affectionately called the "Bible" by graffiti artists worldwide. Her book, *R.I.P.: Memorial Wall Art*, looks at memorial murals in NYC, while *Hip Hop Files 1980-1984* contains hundreds of rare, early Hip Hop photos. *We B*Girlz* is an intensive look at the world of B-girls worldwide, and *Street Play* and *New York State of Mind* showcase her New York City photos from the late 70s.

Martha's work has been widely exhibited in museums and galleries and published in numerous magazines from *National Geographic* to *Vibe*. She lives in Manhattan where she is the Director of Photography at City Lore, the New York Center for Urban Folk Culture.

*Photos on Pages:* 5, 12, 13, 26-27, 74, 75, 77, 78-79, 85, 86-87, 94, 117, 118-119, 122-123 , 124-125, 127

## DIRK MATHESIUS

*www.dirk-mathesius.de*

*Photos on Pages:* 6-7, 9, 12, 19, 20-21, 23, 24, 25, 56-57, 70-71, 72-73, 74, 88, 91, 93, 95, 97, 109, 112-113

## HELGE TSCHARN

*www.helgetscharn.com*

Helge Tscharn is a German photographer, born in 1965, and has been shooting photos since he was 12. He is perhaps best known for documenting the world's skateboarding and music scene. For 15 years he was the photo editor of Germany's biggest skateboarding magazine, *Monster*. He has worked for several art magazines and was the main photographer for the music magazine *Spex* in the 1990s. He has published several books and his work has been featured in various exhibitions. Helge Tscharn is currently living in Florianopolis/Brazil and is working on his new book *Urban Secrets*, based on the idea of skateboarding and architecture.

*Photos on Pages:* 13, 42-43, 51, 64, 67, 81

## MARTIN NINK

*www.nink-photo.com*

*Photos on Pages:* 10, 11, 13, 18, 19, 24, 29, 45, 84, 85, 121, 128-129, 147

## JÜRGEN GROSSE

*www.urban-art.info*

Jürgen Große began documenting outdoor art in the late 1980s. Following several preliminary projects from 1998 to 2000, he founded "urban-art.info" in 2002 and opened a project space in Berlin's Mitte district. Over the next two years this space would become one of the focal points of a network of local and international artists. At the same time, a selection of his photo documentaries of Berlin street art went online at www.urban-art.info.

2008 will see the release of his first book, *Urban Art Photography*, in collaboration with Die Gestalten Verlag, the relaunch of the website, and a new "urban-art.info"-space.

*Photos on Pages:* 46, 60, 61,62, 69, 76, 78, 79, 89, 104, 105, 106, 107, 120, 132

## JR

*www.jr-art.net*

Beside his own artwork JR also took pictures of other artists.

*Photos on Pages:* 14-15, 17, 22, 23, 25, 46, 47, 48, 49, 50, 52-53, 54-55, 90, 91, 96, 104

A few of the artists themselves, along with some of the organizers and helpers, also took photographs. Photos and film stills where taken by Volker Sattel.

# THEY COME AT NIGHT
## FILM BY VOLKER SATTEL & MARIO MENTRUP

The filmmakers follow the gaze of the artists. The film is less a documentary and more a further aspect of this decided form of perception and appropriation of urban space. We see the signs of a city as they present themselves, those which are left behind by its inhabitants and those the artists will add; some flattering, some unnerving. The 'who' and 'what' pulling the strings behind the project and the financing of it was always destined to be impetus for discussion amongst the artists, a topic also addressed by the film.

*28 minutes*
*Stereo*
*NTSC, 16:9*
*DVD-5*
*All Regions*
*English Subtitels*

*Crew and Credits:*
*Volker Sattel – Author, Director, Cameraman*
*Mario Mentrup – Co-Writer, Second Director*
*Claudia Basrawi – Assitant Director*
*Kathrine Granlund – Editor*
*Thilo Schmidt – Second Cameraman*
*Nikolaus Woernle – Soundman, Sound Designer, Musician*
*Henniger Ferber – Production Manager*
*Film 1 – Production*

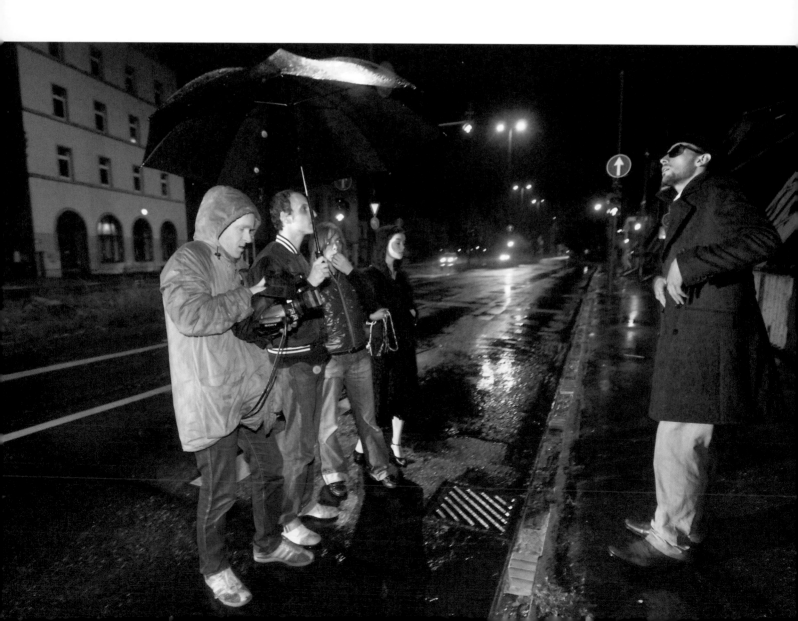

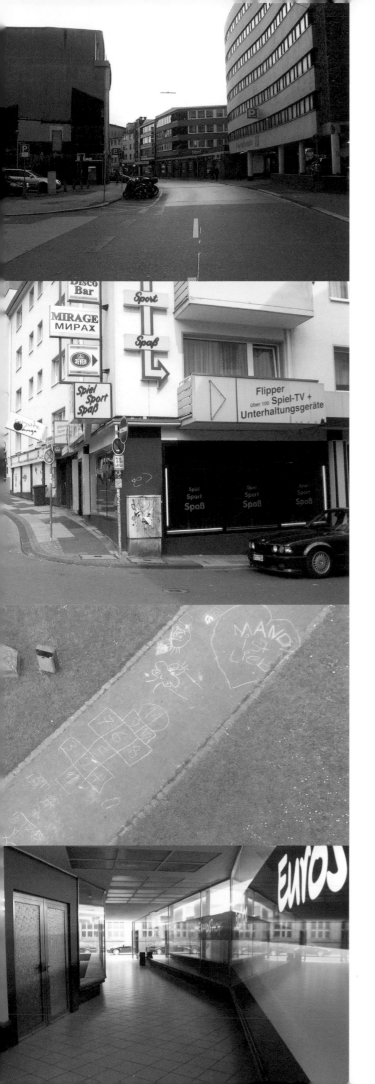

## VOLKER SATTEL ON HIS FILM

My films often deal with architecture and life in the city. I like spending time in cities, mostly I like to wander. I often linger where others hurry by. I'm not so interested in the history of the buildings, streets and plazas. It is more the feeling, the memories or associations which the places I find arouse in me. As I roamed the streets of Wuppertal researching, lots of images caught my eye. Many of these can be found in the film. While we were shooting the street art projects, we also explored the city of Wuppertal in depth. As far as was possible, we sought to capture the rhythm of the place, the psyche of the city – a former industrial town that has seen better days – also the people living there, who strive to live well where at all possible, and also the grass which has grown over everything. In some corners of Wuppertal, we found ourselves in what seemed like a life-size time capsule looking at faces, fashion, billboards and decorations which most people know from their childhoods. As a filmmaker, I turn to the language of cinema. The street artists would penetrate the pessimistic mood of the city and, without permission, anonymously augment the cityscape with their outsized works. Mario Mentrup and I, indeed the whole of our small team, had no intention of documenting the exciting, action-packed scenes which accompanied the artists' mini-missions. Rather, the murky atmosphere and the dwindling city life seemed the perfect setting for a film-noir in which a maverick band of artists struggle relentlessly for their cause. The artists would then reveal themselves as anti-heroes with their idiosyncrasies and egos. I was fascinated by their willingness to take risks and their delusions of grandeur, their transformations and camouflage as well as their determination, their calm and concentration as they went about their little criminal acts and forays in the streets of the city. The camera observes them until they disappear into the darkness. Following the gaze of the artists, images are created which

141

question the perception and reclaiming of urban space. How does the city show its true colors? What marks do the inhabitants make on it and how do the artists react to that? The street artists respond with their works - they want to shock and offend, and the film gratefully seizes upon this. At times, they address the camera directly. They do not conceal the fact that they are acting on behalf of a major company which is financing their fun.

## MARIO MENTRUP ON FILMING

Of course: "THEY come at night"!!! Blu, Akim, Zevs, JR, Mare and all the others tend to work at night. And this was the crucial point: we, the film team, could hardly film the illegal paint-spray-wipe-poster-sticker acts, perfectly illuminated, in the middle of the night. Thus, the lighting technicians stayed at home and we had our work cut out for us during the six days of shooting (not nearly enough time) trying to keep up with the workload and coordinate with the artists and they with us, as we did not just want to film the before/after effect – i.e. first the wall without street art and then the wall with street art. Communication was required. Volker Sattel and I had a very filmic idea, namely to shoot a sort of documentary série noir and some of the artists or project observers had apparently thought of TV reportages or clips: each-artist-with-a-tiny-hand-camera-while-in-action-plus-interview-plus-forced-humour, one of those "making-of" things. Obviously there were many "don'ts" and "no-goes" on both sides, misunderstandings and annoyances. But it did not harm the film - quite the opposite in fact. The constant tension resulted in exactly the right type of potential energy which we needed. Claudia Basraw was the so-called "good cop" as assistant director - she maintained the lines of communication between the artists and ourselves and interviewed most of them. I, as second director, was the "bad cop" and defended our idea, "docu-série-noir" and communicated our

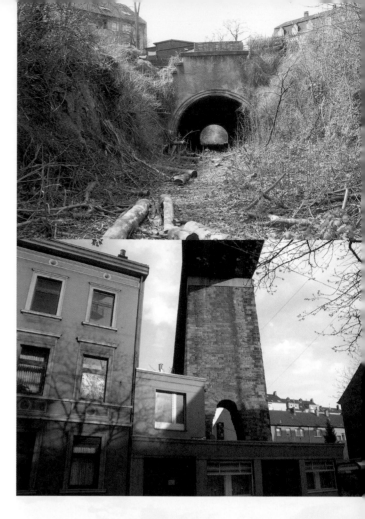

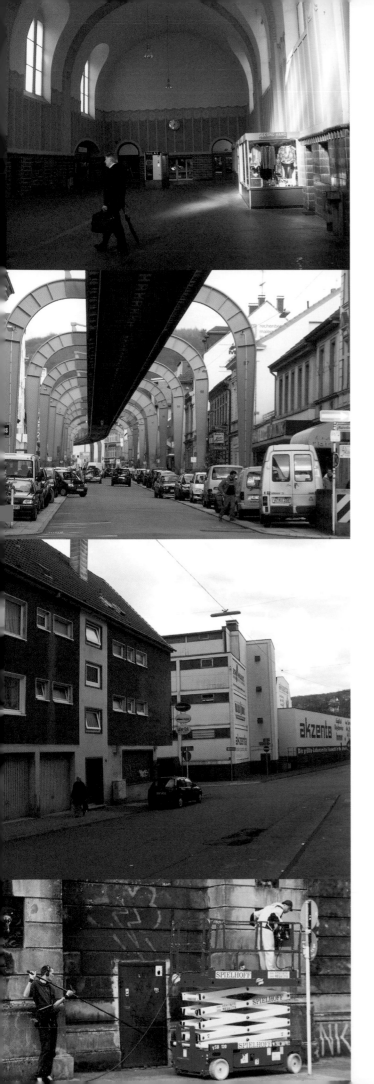

no-goes to the artists and makers only to then let good cop, Claudia, give them some free rein once more. At the end of the day we reached agreement with most of the artists on the stylistic approach to the film and the documentation of their once-off acts. Nikolaus Woernle, our sound guy, had his ears everywhere: interviews, secretly recorded conversations in the villa where artists hung out, as well as atmosphere and exterior recordings around the clock – non-stop. Director Volker Sattel and his second cameraman Thilo Schmidt filmed and filmed and filmed at different locations simultaneously until they could go on no longer. Ultimately, we were able to capture situations with Zevs which were completely unplanned and the spontaneous decisions by the artists, on-location so to speak, to completely discard their original concept but still continue, so that we could obtain usable material, helped us to secure some fantastic cinematic shots. The really quite egocentric JR roped in the whole team for his project, to play a practical joke on the city and the authorities of Wuppertal by committing an illegal act at night, publicly, well-illuminated, and with the police present whilst allowing himself to be filmed – only to disappear again, with us, into the dark night.

# WWW.OUTSIDES.DE

Curated by:
*R.K.D.U. & Thomas Wiczak*

Enabled by:

# WE COME AT NIGHT

Layout by: *Frank (esher) Lämmer*

Edited by: *Frank (esher) Lämmer, R.K.D.U.*

Text contributions by: *Zevs, Zasd, Nixfitti, Mr. Horse, Mare 139, Hitotzuki, JR, Kalliopi Voikou, Blu, Brom, Wolfgang Ullrich, Franz Liebl, Volker Sattel, Mario Mentrup*

Translations: *Lena Junker, Adam Ailsby, Leif Erichsen*

Proofreading: *Chantal Clifford, Leif Erichsen*

Typefaces: *Franklin Gothic, Adobe Jenson Pro*

Production management: *Red Bull*

Printed by: *Pinguin Druck, Berlin*

*Made in Europe*

Distributed by: *Gestalten, Berlin (www.die-gestalten.de)*

ISBN 978-3-89955-216-4

© *Red Bull Deutschland GmbH, 2008*

*Bibliographic information published by the Deutsche Nationalbibliothek.*

*The Deutsche Nationalbibliothek lists this publication in the Deutsche Nationalbibliografie; detailed bibliographic data is available on the Internet at http://dnb.d-nb.de.*

*Respect copyright, encourage creativity!*